THE
DAY
OF THE
DEAD

LAURENCE KING

First published in Great Britain in 2021 by
Laurence King Publishing Ltd
Carmelite House
50 Victoria Embankment
London EC4Y 0DZ

An Hachette UK Company

1 3 5 7 9 10 8 6 4 2

© Chloë Sayer 2021

A CIP catalogue record for this book is available
from the British Library.

ISBN 978-1-78627-725-1

Origination by DL Imaging
Printed in China by C&C Offset Printing Co., Ltd

Designer: Florian Michelet

Laurence King Publishing is committed to
ethical and sustainable production. We are proud
participants in The Book Chain Project
bookchainproject.com®

BOOK
CHAIN
PROJECT

www.laurenceking.com
www.orionbooks.co.uk

**With thanks to Julian Rothenstein of Redstone
Press who provided encouragement as well as
the scans of J.G. Posada's prints.**

A note on the title: "The Day of the Dead" festival
actually covers two days of commemoration in
Mexico (November 1 and 2), and can last even
longer in some regions, so is often referred to in the
plural form—"Days of the Dead"—within the book.

Front cover: José Guadalupe Posada, *¡Gran Calavera
de Emiliano Zapata!*, 1910–13 (detail).
Back cover: Yolanda Andrade, *As You See Me,
You Will See Yourself*, Mexico City, 1990 (detail).

THE
DAY
OF THE
DEAD

A VISUAL COMPENDIUM

Chloë Sayer

Laurence King Publishing

CONTENTS

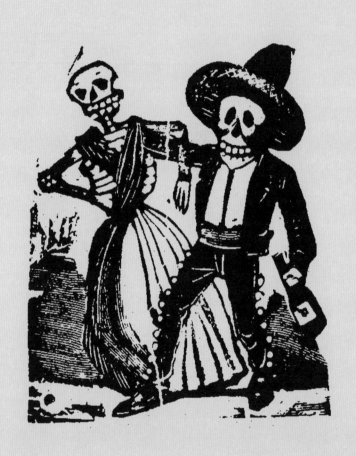

FOREWORD

by Carlomagno Pedro Martínez

The Days of the Dead are as important for the people of Oaxaca as for most Mexicans. Here in the Central Valleys of Oaxaca, this celebration is especially significant for my community, San Bartolo Coyotepec. Founded long ago by the ancient Zapotec, we remain extremely proud of our Zapotec heritage.

If I think back to my childhood, when I was five or six years old, I remember my grandmother Herminia preparing a week early for the arrival of *los fieles difuntos* (the faithful departed). Although she lived simply and wasn't a fancy cook, her mood became festive. I liked to watch her grinding *cacao* for the drinking chocolate and chili to make *mole* (spicy sauce). She always had enough money saved to buy fruit, sweet breads, candles, and *copal* (incense) in the local markets, where the atmosphere was cheerful and celebratory. I enjoyed the exuberant mood on the ramshackle buses that carried us into the City of Oaxaca, and the general merriment as people searched for the things they needed to celebrate the return of the souls. I was moved and excited as a child by the sight of such abundance: the fruit, the *cempaxúchitl* (marigolds), and the white flowers that people in Oaxaca like to offer the dead. A month or two before the festival, we could already feel the arrival of *el aire de muertos* (the wind of the dead)—this told us that winter was coming.

For me, this celebration has always been more important than Christmas. During the Days of the Dead, festivities bring families together: grandparents, parents, and children gather at home with relatives and *compadres*. The tradition of *compadrazgo*, which establishes formal ties between friends and relatives, remains central. Godchildren visit godparents bearing candles, and are greeted with hot chocolate, sweet breads, and fruit.

As I grew older, I began to make *barro negro* (black pottery), working with my parents and my seven siblings. From October 31 to November 2, we honored *los fieles difuntos* and I remember the awe that I felt. I also remember the jollity and humor, when our young men disguised themselves as skeletons and devils. In a similar spirit, we celebrated the local carnivals before Easter, the saints' days dedicated to St. Peter and St. Paul in June or July, and festivities for *la Virgen del Carmen* (Our Lady of Mount Carmel). Long ago, the Zapotec organized feasts to honor Centéotl, Xilonen, and Pitao Cozobi, the maize deities, and Pitao Cosijo, god of rain, thunder, and lightning. Before Christianity, those were the gods venerated by local people.

In Indigenous communities like mine, artists give a visual form to their experiences. From my earliest childhood, I channeled what I was feeling and seeing into my work. I remember being especially struck by a holy Catholic picture of St. Camilo: as he lay in agonies on his deathbed, he exemplified the "good death." He was accompanied by a priest, but the picture also showed demons and the figure of Death. This image has clearly influenced my artistic output, which often features skeletons and devils.

During the Days of the Dead, great importance is always given to the *ofrenda*—the offerings that we set out in our homes. The *ofrenda* can be visually splendid, because it is our way of commemorating *los fieles difuntos*. We include sugarcane, peanuts, walnuts, and candles; we burn *copal* (incense) with its aura of mysticism. Whenever I smell these aromas, they take me back to my childhood. They are deeply embedded in our culture; they are part of Mexico's intangible heritage.

Year on year, my respect grows for our traditional celebrations. Anyone arriving in the City of Oaxaca during the Days of the Dead, faced by the vitality and spectacular scale of this festival, will appreciate its importance. Visitors see an avalanche of celebrants; they can watch *comparsas* (dance groups) performing in the cemeteries, and admire meticulously organized *ofrenda* contests with competing displays of offerings. Throughout this crucial time, the inhabitants of Oaxaca City are drawn back to their cultural origins, rooted in the great civilizations of ancient Oaxaca.

As I grew older and matured as an artist, I became increasingly fascinated by these forms of cultural expression. That is why—in the early 1990s—

I started to develop a plan for a regional museum. El Museo Estatal de Arte Popular "Oaxaca" (The State Museum of Popular Art for Oaxaca) started life approximately 24 years ago, but opened in its present building in 2004. Ours is a community museum, committed to showing work by the First Nations of Oaxaca from eight distinct regions. It is a marvelous adventure to live day by day with popular art, which I regard as "genuine" art in its truest sense. These forms of expression have been passed down from generation to generation by the Indigenous peoples of Oaxaca.

The immense admiration that I feel for Mexican popular art is shared by Chloë Sayer. When we became friends in the late 1990s, I already knew her work. Her many books, whether devoted to textiles or to other forms of cultural expression, have given a voice to Indigenous creators. With respect and integrity, she has promoted Mexican culture over many decades, documenting the traditions and artistic achievements of countless communities. Sometimes we have worked together. In 2008, I lent ceramic sculptures and gave workshops at the Gardiner Museum in Toronto for the exhibition "Harvest of Memories: Mexican Days of the Dead." In 2012, when the Art Gallery of Ontario showed paintings by Frida Kahlo and Diego Rivera, I created a site-specific *ofrenda* to honor both artists. By the end of the exhibition, this had become a collective shrine, with visitors adding photographs and letters for their deceased friends and relatives.

As Chloë knows, death has been a recurrent theme in my work. Octavio Paz, the poet and essayist, once famously declared that death is our dearest love. I remain inspired by the great José Guadalupe Posada, and marvel at the timeless power of his engravings. I admire the work of twentieth-century artists like Roberto Ruiz: born in the Oaxacan town of Miahuatlán, this great carver of bone portrayed death in all its guises. Of course, many makers are destined to remain anonymous. Each year, when the Days of the Dead arrive, street markets fill with the output of wood carvers, toy makers, miniaturists in pottery, and sugar-workers. Their work confirms the visual appeal of this festival and links us with our past. It gives me great pleasure, therefore, to write these words of introduction for a book about death and its enduring cultural role in contemporary Mexico.

Carlomagno Pedro Martínez

Ceramic artist, awarded the Premio Nacional de Ciencias y Artes in the category of Arts and Traditions in 2014. Director, Museo Estatal de Arte Popular "Oaxaca," San Bartolo Coyotepec, Oaxaca

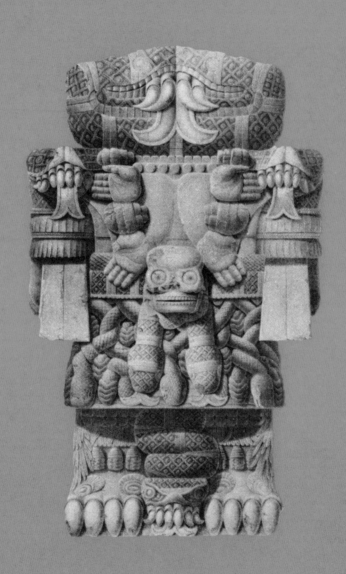

INTRODUCTION

In Mexico, November 1 and 2 belong to the dead.

According to popular belief, the deceased have divine permission to visit friends and relatives on Earth and to share the pleasures of the living. To an outsider, celebrations might seem macabre, but in Mexico death is seen as part of life. A familiar presence, it is portrayed with affection and humor by artists and craftworkers throughout the year.

The modern view of death derives in part from that of pre-Hispanic times. The Aztecs, who called themselves the Mexica, were the last in a succession of great cultures. Like other ancient peoples, they served a complex pantheon of gods and sought their favor with offerings, ceremonies, and festivals. Neither kind nor cruel, these ambivalent deities were represented in a range of materials, including stone and pottery, and portrayed in codices (painted manuscripts). Coatlicue (Serpent Skirt), goddess of the earth and death, was portrayed with a necklace of human hearts and hands from which hung a skull pendant; her head was formed by two serpents, symbols of flowing blood. In ancient Mexico, death signified not an end, but a stage in a constant cycle. Just as day followed night and spring followed winter, so the continuity of life was ensured by heroic death and sacrifice. The death of the individual was seen as a journey for which numerous offerings were needed.

Opposite Carl Nebel, lithograph showing a stone carving of the Aztec goddess Coatlicue, c.1830

In Christian Europe, by contrast, death was also seen as a journey, but the destination was either glory or eternal damnation. Believers lived in fear of the Last Judgment, when the soul's fate was determined. The *danse macabre* (dance of death), portrayed in medieval paintings and carvings, showed death as an equalizer, striking down rich and poor, powerful and weak.

The Spanish Conquest of 1521 brought about the fusion of Roman Catholic attitudes and Indigenous beliefs. Missionary priests imported the European custom of staging "morality" plays and allegorical pageants to dramatize the Christian abstractions of virtue and sin. Spanish settlers introduced the European cycle of religious festivities, including All Saints' Day and All Souls' Day. All Saints' Day, first celebrated on November 1 by Pope Gregory III in the eighth century, is inextricably linked with All Souls' Day. This annual event was established in France in the late tenth or early eleventh century, when St. Odilo (c.962–1049), the Benedictine Abbot of Cluny, asked his monks to devote their prayers to the departed on November 2. This yearly commemoration was soon adopted throughout the Western Church. In parts of Italy and Spain, both feasts attracted beliefs and practices that were popular but not orthodox. For example, it became common for families to set out offerings in cemeteries, in the hope that they would win the protection and blessing of the souls on their yearly return to Earth from heaven.

In modern Mexico, festivities for the dead are idiosyncratic. Blending pre-Christian and Christian elements, celebrations for All Saints' and All Souls' are unique in the Catholic world. Mexicans are as tormented by the idea of mortality as other nations, yet they honor and receive the departed with unstinting generosity. It is not a somber occasion, but a time of feasting and reunion. In 2008, the significance of this tradition was recognized internationally when it joined UNESCO's List of Intangible Cultural Heritage of Humanity. The complex relationship Mexico has with death was famously discussed by the poet Octavio Paz (1914–1998) in *El laberinto de la soledad* (The Labyrinth of Solitude), first published in 1950. Paz wrote: "The word 'death' is not pronounced in New York, Paris or London because it burns the lips. The Mexican, by contrast, is familiar with death, jokes about it, caresses it, sleeps with it, celebrates it; it is one of his favorite toys and his most steadfast love. True, there is perhaps as much fear in his attitude as in that of others, but at least death is not hidden away …"

As Paz also noted, Mexicans are a supremely festive people. This is especially true in rural areas. Roughly 80 percent of all Mexicans now live in towns and cities, but the Mexican countryside is still home to a large number of Indigenous cultures. According to the 2005 census, 65 Indigenous languages were spoken by approximately 6 million people that year. Festivities for the dead, shaped by local beliefs and customs, vary widely from region to region. Náhuatl, the language of the Aztec empire, is spoken by some 2 million people who are known today as the Nahua. The Nahua celebrate the arrival of their dead with respect and deep affection. So do the Otomí, the Mazahua, the Zapotec, the Mixtec, the Maya, and most other descendants of ancient Mexican cultures. Predictably, urban populations in Mexico City and elsewhere take an ever-evolving and more exuberant approach to seasonal celebrations.

The theme of death motivates many artists and craftworkers. Skeletons —whether made from sugar, wood, tin, painted pottery, or papier-mâché—are participants in a modern dance of death, as they caricature the activities of everyday life. The influence of the nineteenth-century Mexican *calavera* is clear. The *calavera* (skull) was a type of broadside that featured mock epitaphs for the living. Accompanying images showed personalities and professions of the era as skeletons. Sold on All Souls' Day, the *calavera* carried humorous verses and provided an opportunity for political satire and biting social comment. Although there were many *calavera* artists, two stand out, Manuel Manilla (c.1830–1895) and José Guadalupe Posada (1852–1913).

Because Manilla preceded Posada, and since much of his work has been lost, his pioneering role in the development of the *calavera* has been largely overlooked. In many instances, Manilla's images have even been mistakenly attributed to Posada. Both artists were endlessly productive and inventive. Over many years, each illustrated a succession of devotional booklets, song sheets, children's tales, news stories, theater announcements, riddles, and board games, in addition to the *calaveras* that are so much better known today.

Today, members of the Linares family, brilliant papier-mâché artists and famous representatives of modern Mexico, continue to breathe life into Posada's witty and uniquely Mexican images of death (see Chapter 6).

1

DEATH IN MEXICO:
THE LONG VIEW

Although modern Mexico is predominantly Roman Catholic, pre-Christian beliefs and practices remain an important force.

Nearly 500 years of conquest, colonization, and change have not erased the legacy left by pre-Hispanic cultures. Death, for the ancient peoples of Mexico, was a stage in a constant cycle that paralleled the yearly sequence of the seasons: after the dry period, when vegetation died, the rains brought new growth. The Aztecs, who rose to power after 1325, regarded life and death as complementary. Ritual killings were seen as indispensable to the equilibrium of the universe. By offering the hearts and blood of sacrificial victims, usually captives, Aztec priests renewed the progression of the seasons and ensured the rebirth of life. Without this vital nourishment, it was thought, the gods would lose their life force and the sun would lose the strength to rise each day.

Imagined vertically, the Aztec universe incorporated 13 celestial planes, our own terrestrial level, and nine planes of the underworld. Mictlan, the ninth and deepest level, was the cold and shadowy realm of the death god Mictlantecuhtli and his female counterpart Mictecacihuatl. Imagined horizontally, the universe was determined by the four cardinal points. North was the direction of death and cold. Known as Mictlampa, the region of death, it was associated with the colors black and yellow.

The afterlife was determined by the manner of death. Warriors who died on the battlefield were rewarded for their valor. From dawn until midday, they followed the celestial path of Tonatiuh, the sun god. After four years, they became hummingbirds. Women who died in childbirth, regarded as another form of battle, accompanied the sun from midday to dusk. Known as the *cihuateteo*, these malevolent spirits were portrayed with skull faces. Tlalocan, the lush "paradise" of the rain gods, was reserved for people who died a watery death.

Dead infants went to a special place where a tree dripped milk from its leaves. Most people, however, made the hazardous four-year journey to Mictlan. The Aztec solar year, divided into 18 periods ("months") of 20 days each, included several feasts associated with cults of the dead. Miccailhuitontli and Miccailhuitl, held in the ninth and tenth "months," honored the Little Dead and the Adult Dead. There was feasting and dancing, flowers were strung together, and offerings of food included *tamales* (steamed portions of maize dough filled with the meat of dogs and turkeys).

The Aztecs were not alone in their religious beliefs. As the inheritors of cultural traditions that were many centuries old, they shared their cosmology and their pantheon with the other inhabitants of ancient Mexico. Representations of skulls, skeletons, and human sacrifice abound, not just in Central Mexico, but also on the Gulf Coast and among the Maya. After 150CE, the preoccupation with death intensified. Ball courts, where life-and-death ball games were played, often displayed carved stone panels on which scenes of human sacrifice evoked new life. Those at Chichén Itzá in Yucatán show serpents and a flowering plant bearing fruit issuing from the neck of a sacrificial victim.

Spain's epic conquest of the Aztec empire was completed in 1521. This was followed by the overthrow of the Tarascan empire in West Mexico, the oppression of the peoples of Oaxaca, and the eventual subjugation of the Maya populations of the Yucatán Peninsula, Chiapas, and Guatemala. The arrival in 1535 of the first Spanish viceroy marked the start of the colonial period in New Spain, as Mexico was known until Independence in 1821. Churches and monasteries were erected, often on the site of earlier shrines. Indigenous books were burned and idols smashed. During the first 50 years of colonial rule, the work of conversion was carried out in large part by mendicant friars. The Franciscans were the first to propagate the Christian faith; soon they were joined by the Dominicans, the Augustinians, and, in the 1570s, the Jesuits. These missionary priests introduced the concepts of heaven, hell, and purgatory as rewards or punishments for deeds done in life, together with the Christian abstractions of virtue and sin. Devotional books, often finely illustrated and produced on Spanish printing presses, promoted Roman Catholic teachings and stressed the importance of dying a "good death." The annual cycle of festivities celebrated throughout New Spain included the feasts of All Saints and All Souls on November 1 and 2.

Over time, most Indigenous populations adopted Christianity, but this acceptance was often colored by residual beliefs. Agricultural rituals were incorporated into the annual Catholic cycle, while Christian saints took on the traits of pre-Christian deities. Predictably, the feasts of All Saints and All Souls combined cultural traits from Europe, both orthodox and unorthodox, with existing traditions. Writing in the late sixteenth century, the Dominican friar Diego Durán noted with regret that these Christian festivals had Aztec undertones. He watched celebrants making offerings of chocolate, candles, fowl, and fruit, and guessed that they were perpetuating pre-Hispanic rites for the dead.

Spanish settlers brought a rich funereal iconography to their new colony. Death was shown in the European manner as a skeleton with a scythe. Skulls, emblems of physical death, were paired with the Cross to symbolize Christ's Resurrection and the promise of salvation and eternal life. By the second half of the eighteenth century, however, representations of death were becoming notably more festive. Francisco de Ajofrín, a Capuchin friar from Spain, saw coffins, tombs, bishops, and other figures made with "exquisite workmanship" in Mexico City in 1763–4. In 1778, the Jesuit priest Juan de Viera described the sugar-paste coffins, birds, fishes, pitchers, and lambs that were sold in the porticos of the capital on November 1 and 2. Then, in 1792, a controversial and fantastical book appeared: *La portentosa vida de la Muerte, emperatriz de los sepulcros, vengadora de los agravios del Altísimo, y muy señora de la humana naturaleza* (The Portentous Life of Death, Empress of Sepulchers, Avenger of Wrongs against the Almighty, and Mistress of Human Nature). Written by the Franciscan friar Joaquín Bolaños, and magnificently illustrated with copper engravings by Francisco Agüera Bustamante, the book tells the story of Death. The life of this female protagonist, shown throughout as a skeleton, parallels that of a human being: she is born, has various adventures, grows old, and dies.

In his prologue, the author explains his desire to amuse his readers. While he hopes to convey the mystique of death, he plans to lighten the topic with charm and "a touch of jest." Criticized at the time for its levity, this book was an indicator of changing tastes. In the words of the bibliophile and writer Mercurio López Casillas (b.1964), the author's ironic vision of death "laid the foundations of a new identity," while the engravings of Agüera Bustamante marked a visual departure from the European style.

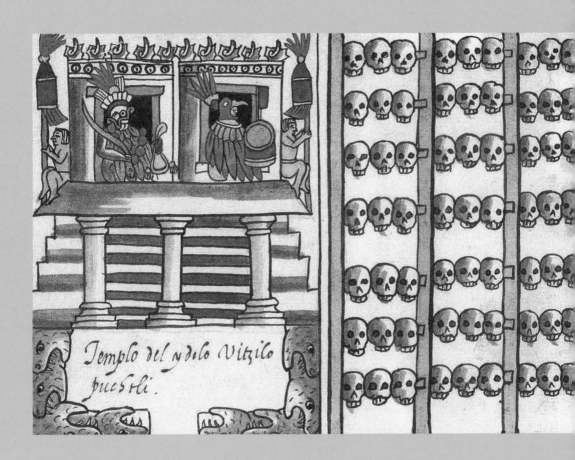

Within the illustration: *Templo del ydolo Vitzilopuctoli.*

Aztec *tzompantli* (skull rack) and temples from the Codex Tovar, c.1587

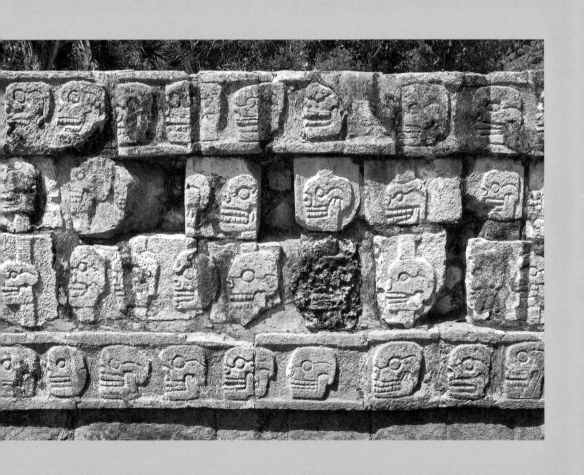

Stone wall with carved skulls representing a skull rack in
the Maya city of Chichén Itzá, Yucatán, c.1200CE

This novel approach, shocking in its day, paved the way for the Mexican *calavera* and the late nineteenth-century work of Manuel Manilla and José Guadalupe Posada, whose engravings are deeply rooted in the national culture. Manilla's style was closer to the woodcuts of the colonial period, but Posada was able to embrace newer engraving methods that gave his work greater fluidity of line. His most important client was the printer-publisher Antonio Vanegas Arroyo (c.1850–1917). Although Posada was buried in a pauper's grave, his work found new admirers during the decades that followed the Mexican Revolution. The artist Diego Rivera (1886–1957) paid tribute to Posada in his vast mural *Sueño de una Tarde Dominical en la Alameda Central* (Dream of a Sunday Afternoon in the Alameda Central, see pages 122–3). As Rivera noted, "In Posada's work everything and everybody is caricatured as a skeleton, from the cat to the cook, from [President] Porfirio Díaz to [revolutionary peasant leader] Zapata, including the farmer, the artisan, and the dandy, not to mention the worker, the peasant, and the Spanish colonizer."

The festive character of All Saints' and All Souls' Days intensified with the cultural renaissance that followed the Mexican Revolution (1910–20). Under the leadership of intellectuals, such as José Vasconcelos, the minister for education, Indigenous cultures and regional traditions were admired and celebrated. The artists Diego Rivera and Frida Kahlo (1907–1954) embraced popular culture with enthusiasm and commitment, as is evidenced by photographs taken in their home, which show pottery and papier-mâché objects for the Days of the Dead. Indeed, in his studio, Rivera had enormous wire and papier-mâché skeletons, known as "Judas" figures, that were made for Holy Week by Carmen Caballero Sevilla. When Rivera was encouraged by Vasconcelos to paint a series of murals in the Ministry of Public Education, he included a fresco showing Purépecha villagers in the state of Michoacán holding an all-night vigil for the souls. A companion fresco showed the Day of the Dead in Mexico City, replete with sugar skulls, skull masks, and skeleton puppets. In Kahlo's self-portrait *The Dream* (page 74), the sleeping artist is paired with the skeleton Judas figure that she kept on the canopy of her bed. It was, she told visitors, a reminder of her own mortality.

When the Russian filmmaker Sergei Eisenstein (1898–1948; see page 56) traveled through Mexico in 1931 looking for inspiration, he was immensely struck by the omnipresence of death. He wrote later in his memoirs, "November

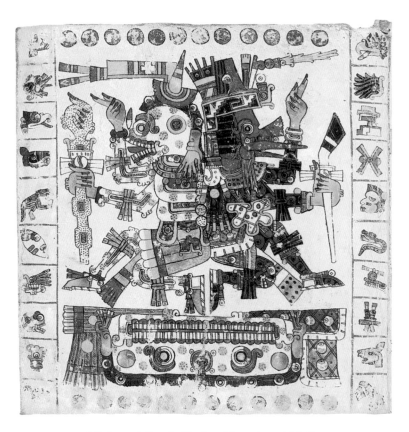

Mictlantecuhtli, god of death and the underworld (left)
from the Codex Borgia, c.1500

the 2nd, 'Death Day,' is given over to irresistible mockery of death ..." Eisenstein
decided that *¡Qué Viva México!*, the film he was planning to make in Mexico,
would incorporate four sections plus a prologue and an epilogue. Before he
could complete his project, however, funding was withdrawn. Eisenstein's most
ambitious film project was destined to become his greatest personal tragedy.
The scenes he filmed for the epilogue, dedicated to Posada, were later put
together as a short film called *Death Day*. Shot on the roof of the Hotel Regis
in Mexico City, these scenes evoke Mexican celebrations for the souls of the
deceased. In Mexico, as Eisenstein wrote, "The overlapping of birth and death ...
is visible at each step ... life and death fuse constantly; so too do appearance and
disappearance, death and birth ... the paths of life and death intersect in a visual
way, as they do nowhere else ..."

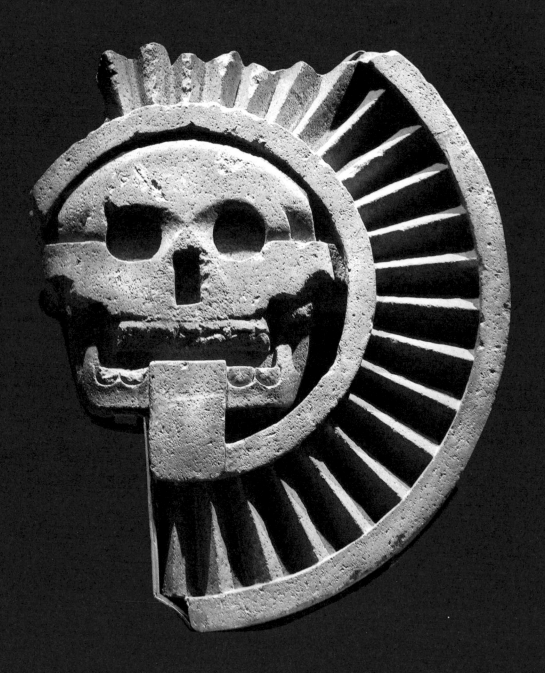

Stone sculpture of Mictlantecuhtli, god of death, from Teotihuacán, 1–650 CE

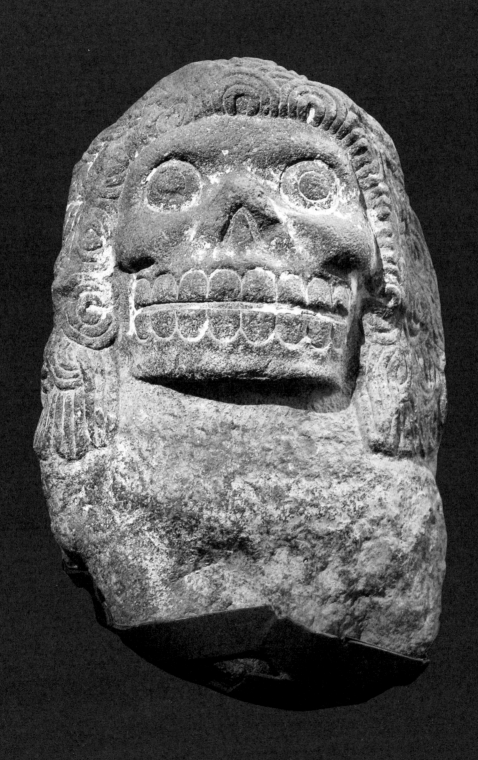

Stone sculpture of a *cihuateotl* (malevolent female spirit with skull face),
Aztec culture, 1300–1521

The transition from life to death inspired many sad and haunting songs in Pre-Christian Mexico. Composed in the Náhuatl language by the Aztec élite, they describe life as a fleeting moment—a dream—from which death awakens us.

It is not true that we live,
it is not true that we endure on earth.
I must leave the beautiful flowers,
I must go in search of the mysterious realm!
Yet for a brief moment,
Let us make the fine songs ours.

Anonymous poem, Chalco

We come but to sleep,
we come but to dream:
It is not true, it is not true,
that we come to live upon the earth.
Like the grass each spring
we are transformed:
our hearts grow green,
put forth their shoots.
Our body is a flower:
it blossoms
and then it withers.

Anonymous Aztec song-poem composed in the
Náhuatl language (late 15th–early 16th century)

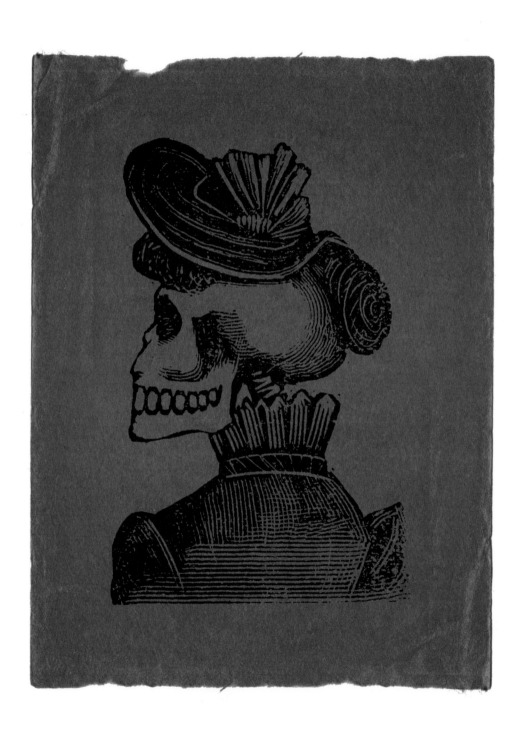

Above José Guadalupe Posada, Skeleton woman from *La Calavera de Cupido*, 1890–1913
Opposite Francisco Agüera Bustamante, Engraving from *The Portentous Life of Death*, 1792

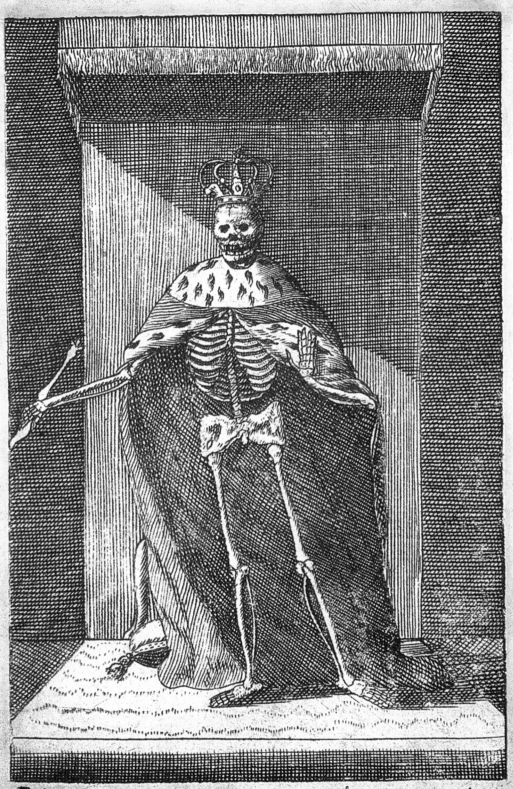

Dixit: Cogitationem suam in eo esse ut omnem teram suo Subjugaret Imperio. Judit. cp. 2.

Exaudi me miseram depræcamtem! Judith. 9

Above Francisco Agüera Bustamante, engraving from *The Portentous Life of Death*, 1792
Opposite Manuel Manilla, *Cacophony of Skeletons*, 1882–92

Rebumbio de Calaveras de Catrines y Borrachos
DE VIEJOS Y DE MUCHACHOS
DE GATOS Y GARBANCERAS

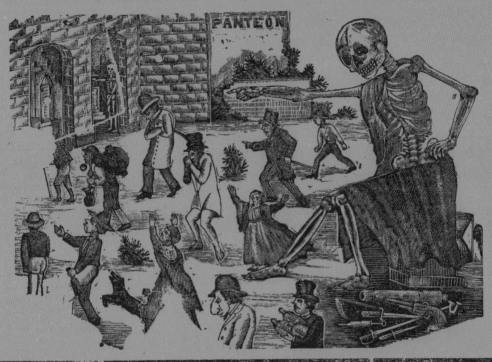

De este esqueleto la huesuda mano
Su fin indica al desgraciado humano

Esta muerte inflexible nos señala
Cual de la eternidad es la antesala.

Las criaditas en montón
Tan coquetas y habladoras
Ya marchan para el panteón
Muy tiesas y meneadoras.

Remilgosas garbanceras
Con mantecota alisadas
Se quedan alli clavadas....
¡Pobres! ¡pobres calaveras!

¿Y los gatos en dos piés?
Quiero decir: los sirvientes,
Esos van dando traspiés,
Ya calaveras sin dientes.

Es una ley bien tierna
Y no hay quien la haga variar,
Que toda la raza humana
Al panteón ha de ir a dar.

Las rotas de vecindad
Que se hacen el copetón,
Ya la muerte les señala
El camino del panteón.

La viuda desconsolada
Que por su muerto se apura,
Va corriendo desolada
A dar a la sepultura.

El sirviente que en sus viajes
Suele siempre dilatarse,
Más ligero que una pluma
Irá al panteón a enterrarse.

Aquel que se enriqueció
Siendo un terrible usurero,
Al panteón ha de ir a dar
Con todito su dinero

El borrachito simplón
Que siempre armaba querella,
Cuando se vaya al panteón
No olvidará su botella.

El indio mantequillero
Que se le hecha de formal,
Cuando a enterrar se lo lleven
Irá con todo y huacal.

Aquel viejo narigón
Que fue siempre un atontado,
Se irá solito al panteón
Donde será arrinconado.

El picaro jugador
Que jugó hasta el pantalón,
En camisa y con sorbete
Llorando se irá al panteón.

El calavera artesano
Que gastó siempre su raya,
Ni quien le rece un sudario
Cuando ya al panteón se vaya

El médico, el cura, el loco,
El poeta, el artesano,
Todos irán, poco a poco,
Caminando al camposanto.

Las costureras de modas
Y las de encuadernación,
Marcharán llorando todas
A las puertas del panteón.

ES PROPIEDAD.—Tip. de la Test. de A. Vanegas Arroyo. 2ª de Sta. Teresa Núm. 40. México—Precio 5 cts.

CALAVERA DE LA
DE LA PRENSA

TONCHO VANEGAS ARROYO,
en todo está, en todo piensa;

allá desde el profundo hoyo
*escribe para la **Prensa**......*

Y les manda sus saludos
más expresivos y atentos
al «Demócrata» y «Excelsior»
y a los diarios oportunos.

«Don Quijote,» «Universal,»
«El Monitor Comercial».
«Arte Gráfico,» «Opinión,»
«El Popular,» «Rebelión»

«Monitor Republicano,»
igual «La Prensa Asociada,»
«Revista Mundial,» «Alianza»
«El Hogar,» El Mexicano».

Y a «Revista de Revistas»
como al «Heraldo de México»
y al «Boletín Financiero»
les saluda. A esos prensistas.

Esos rápidos cajistas
que no temen rotativas,
y que les dan el quién "chilla"
a los hoy linotipistas.

A todos los que en los tipos
saben darse tipo y garbo,
su calavera les mando
para que calmen sus hipos.

A los relajos y raspas
como "El Fifí" y "El Chiquito"
me prestan para mí... ahorrito
tres "cuartillas" y un tostón;

Abranse todos de capas,
"El Mosquito," y sus pendencias,
que aquí les vá «MENUDENCIAS»
un periódico sazón.

"Menudencias" al «Diablito
Bromista» mandó al infierno....
¿Qué se esperará "El Chiquito"
¡Que lo ensarten como a yerno?

Por léperos y maluras,
y alborota-garbanceras,
verán terminar sus horas,
volviéndose calaveras.

Todos irán al Panteón,
todos se verán difuntos,
unos de esos de ocho puntos
y otros puro clarendón.

Con todo y componedor,
con todo y cajas y plecas,
serán calaveras secas
de glosilla y entre dos.

Esos prensistas chambones
que en prensas de pié chambearon,
todos también se pelaron
por flojos y por rajones.

Esos fatuos correctores
que llegan a revisar,
cuando es hora de formar
empiezan sus correcciones.

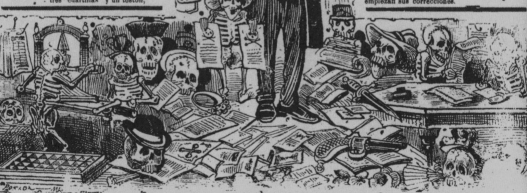

Esos tan....... linotipistas
que el hígado les cociera
'a hirviente y feroz caldera
del plomo.. si no andan listos
Atontadas calaveras.
se les pasan los renglones
y por verlos en galeras
cuando los rotos molones,

Van a recojer las pruebas
ponen con perfidia cursi,
tantas notas como enmiendas,
que parece mapa mundi.
Los fachosos formadores,
pretensiosos remiendistas,
apenas anunciadores
son de los pobres cajistas.

También a los periodistas,
por sus rígidas maneras,
serán todos calaveras....
¡Al panteón con sus "Revistas"
Y esos colaboradores,
serán montón de canillas;
son sólo emborronadores
de desdichadas cuartillas.

Escriben barbaridades,
con desplante y osadía.
y todas sus necedades
no tienen ni ortografía.
Por todas estas tonteras
la Parca infalible piensa
el hacerlos calaveras
del gran Panteón de la Prensa.

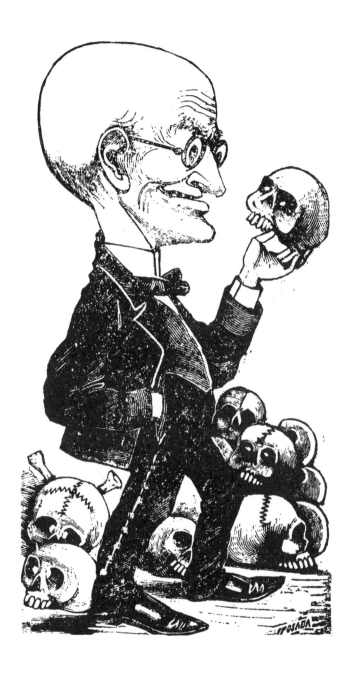

Opposite José Guadalupe Posada, Day of the Dead *calavera* lampooning the Press, 1890–1913
Above José Guadalupe Posada, *Don Chepito with Skulls*, c.1902

Above Manuel Manilla, Skeleton from Guadalajara in *La Calavera Tapatía*, 1882–95
Opposite Constantino Escalante, Day of the Dead caricature published in *La Orquesta*, 1865

A CUATRO LAS PIECESITAS

— Necesito algunas docenas de estas calaveras, para mi Dⁿ Juan Tenorio
que se representa esta noche en el Palacio Imperial

CALAVERAS

ZalameraS de las CoquetaS MeseraS

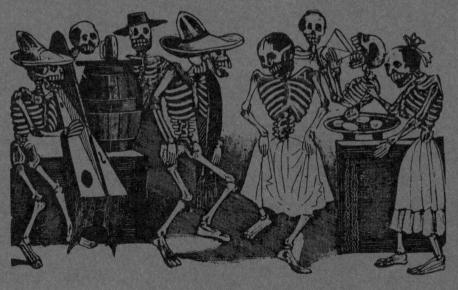

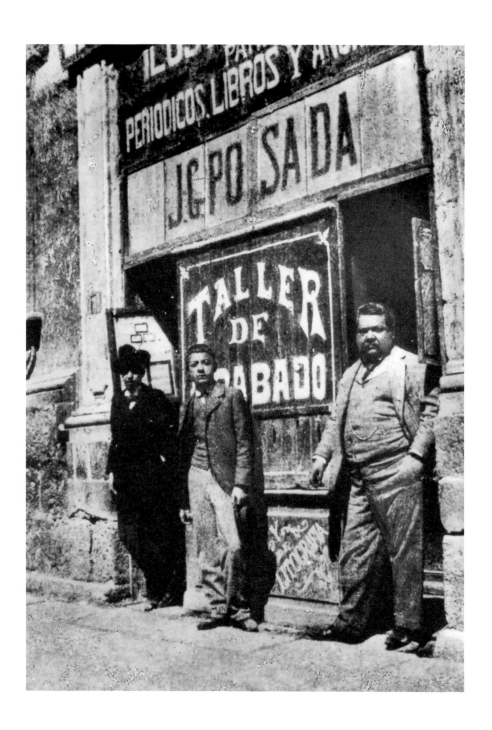

Opposite José Guadalupe Posada, *The Wheedling Ways of Flirtatious Waitresses*, c.1910
Above Posada (right) and assistants outside his print shop, 1900

Above and opposite Romualdo García, Grieving mothers photographed
with their dead babies in the city of Guanajuato, late 19th century

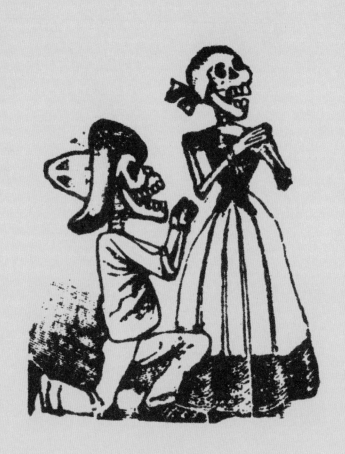

THE WEEPING WOMAN

The Mexican attitude to death finds expression in popular sayings, phrases, and songs. Many of these are humorous. They "normalize" death, reminding us that death is another facet of life. Pre-Hispanic cultures were acutely aware of death, and the same is true of modern societies. In Mexico, it is usual to give friends and relatives affectionate nicknames inspired by their physical traits—*Flaco* (Skinny), *Chaparro* (Shortie), *Gordo* (Chubby)—and the same companionable approach is taken to death itself. In Spanish, *la muerte* (death)—like *la vida* (life)—is a feminine noun, so she is traditionally characterized as female. The examples overleaf translate easily into English. Other terms need an explanation. The historical background of the term "Catrina" is given on pages 111–12. The term *La Parca*, introduced after the Conquest by Spanish settlers, comes from Roman mythology. Morta, the goddess of death, was one of the *Parcae* (Fates) who control our destiny.

Death is also personified as *La Llorona* (the Weeping Woman). Stories of weeping phantoms are not uncommon in Latin America. The Mexican folk song "La Llorona" probably originated on the Isthmus of Tehuantepec. It has been sung by many artists, including Isabel "Chavela" Vargas Lizano in the 2002 film *Frida*: in one memorable scene, she appears as the figure of death to the young Frida Kahlo.

MEXICAN TERMS
FOR LA MUERTE (DEATH)

LA NOVIA FIEL
The Faithful Bride

LA CALACA
The skeleton

LA IGUALADORA
The Equalizer

LA PEPENADORA
The Garbage-Scavenger

LA AFANADORA
The Cleaner

LA DIENTONA
The Toothy Lady

LA APESTOSA
She Who Smells

LA IMPIA
The Unholy Lady

LA PELONA
The Bald One

LA PALIDA
The Pale One

LA HUESUDA
The Bony One

DOÑA FLACA
The Thin Lady

LA DESCARNADA
The Fleshless Lady

LA JIJURRIA
The Malevolent Lady

LA BLANCA
The White Lady

LA TRISTE
The Sad Lady

LA JEDIONDA
The Stinking Lady

LA COPETONA
The Crested Lady

LA PACHONA
The Phlegmatic Lady

LA LIBERADORA
The Liberator

LA GÜERA
The Pale Lady

LA CIERTA
The Inflexible One

PATAS DE HILO
Thread-legs

LA SEGADORA
The Female Reaper

LA DEMOCRÁTICA
The Democratic Lady

LA PATRONA
The Boss

MARÍA GUADAÑA
Mary with a Scythe

LA HUECA
The Hollow Lady

LA HORA SUPREMA
The Decisive Hour

LA POLVEADA
The Dusty Lady

LA JUSTICIERA
The Giver of Justice

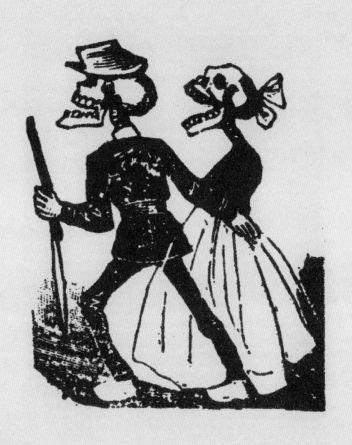

EL DOCTOR

IMPROVISADO

CUENTO

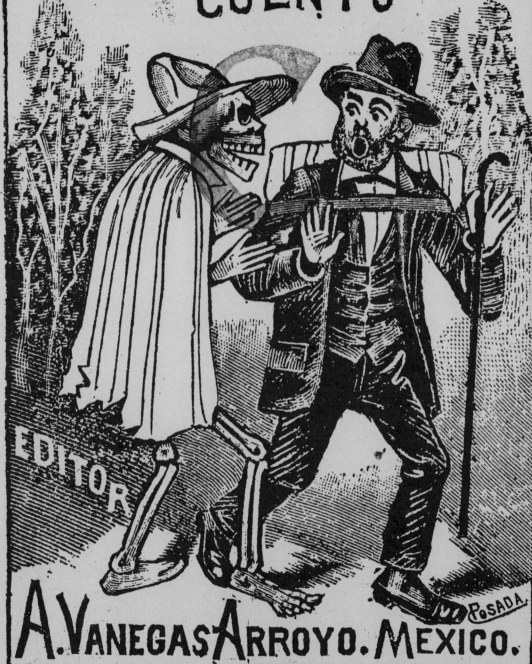

EDITOR

A.Vanegas Arroyo. Mexico.

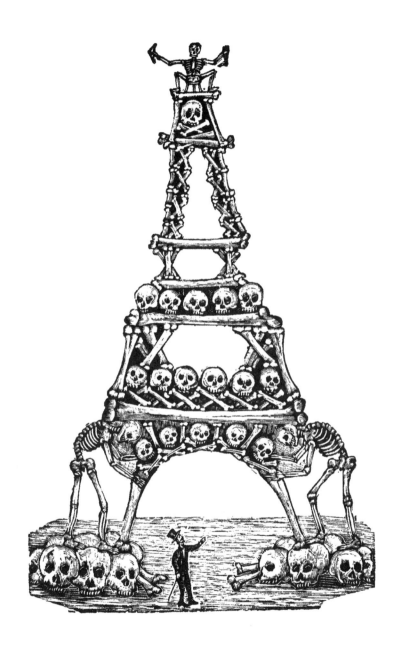

Opposite José Guadalupe Posada, *The Impromptu Doctor*, 1890–99
Above Manuel Manilla, Eiffel Tower in *The Calavera of the Penitentiary*, 1882–92

Como te ves yo me vi,
como me ves te verás.

As you look now I once looked,
as I look now you will look.

Epitaph and popular saying

Opposite José Guadalupe Posada, *Calavera de las Artes*
showing artisans as skeletons, 1890–1910

CALAVERA DE LAS ARTES

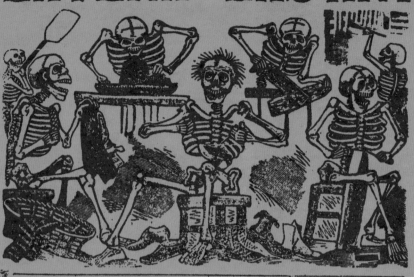

Sin pretensión de pobre ni de rica,
Aquí donde me ven valgo una chica.

Se acabaron por fin los artesanos,
Que hoy saludan á todos sus hermanos

Pobres de los carpinteros
Que con el puro cepillo,
Al cedro le sacan brillo
Y al marchante los dineros.
 Ahora en el panteón están
Aserrando duro y fuerte,
Para enterrar á la muerte
En un lujoso cajón
 Se les acabó la busca
De las chambas por su cuenta,
Que hasta el mejor se amedrenta
Cuando la muerte se ofusca.

Los sastres aquí están secos
Como mulas de alquiler,
Pues ya no pueden hacer
Como antes tantos chalecos.
 Ya no se podrán robar
Los pedacitos de paño,
Que aquí no cabe el engaño
Ni hay modo de cercenar.
 Ellos que eran encargados
De vestir á los demás,
Andaban todos cual más
Enteramente encuerados.
 Y por la misma razón
Hoy condenados están,
A hacerle al diablo un gabán,
Un saco y un pantalón.

Aquí están los zapateros
Tan alegres y bromistas,
Que jalan recio á las pitas
Y masetean á los cueros.
 Ellos que arman el mitote
Chándola de valientes,
Son ahora los más prudentes
Porque les entró el cerote.
 Con la muerte aquí no juegan
Por eso están contritos,
Llorarán sus delitos
De los cuales hoy reniegan.

Los talabarteros pillos
Que tuvieron buena suerte,
Le están bordando á la muerte
Cantinas y baquerillos.
 Y aunque ya son calaveras
Las medidas no rehusan,
Y aún allá en el panteón usan
Su leznita y sus tijeras.
 Los finchados sombrereros
Que hasta se escupen la mano
Planchando un rico jarano
Para los buenos rancheros.
 Más lucen su habilidad
En tratando con los muertos
Pues entónces están ciertos
De ir hasta la eternidad.
 Y siendo ya calaveras
También las ribeteadoras,
Se pasarán buenas horas
Siendo amigotes de veras.

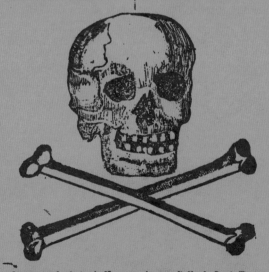

Los enamorados patos
Que embadurnan las esquinas
Y enamoran las catrinas
Pasando así dulces ratos,
 Cuando vayan al panteón
Su trabajo han de tener,
Pues ellos le han de poner
Su nombre á cada cajón.
 Ya no echarán sus julones
Del tlamapa rico y puro;
Ya no ganarán ni un duro
Por pintar los jacalones.
 Ya no se irán con las gatas
A pasear en Todos Santos,
Pues van á los Camposantos
Que hasta les vuelan las patas.
 Los bizcocheros mugrientos
Que andan de la harina en torno,
Harán allá entre los muertos
Calaveritas al horno.

Los impresores de oficio
Que matan el sapo tanto,
Se van todos haciendo equis
Camino del Camposanto.
 Y allí á San Lúnes le rezan
Llenos de fé y contrición,
Pues no olvidan que este Santo
Fue en el mundo su patrón
 Y aunque ya sean esqueletos
Resecos y apolillados,
Todavía se la han de echar
De pillos y enamorados.

Los buenos hojalateros
Que la echan de cosa fina,
Diciendo que no hay como ellos
Para hacer bien una tina,
 Al hacer la gran pirueta
Verán con dolor profundo,
Que el orgullo nada vale
Como nada vale el mundo.
 Se acabaron los faroles
Y las jaulas de pericos,
Ya no harán recojedores
Ni coches para los chicos.
 Aquellos de Michoacán
Que á México están viniendo,
Para el panteón se irán yendo
Y ya de allí no saldrán.

Ya el mamonero no canta
Estando allá en el panteón,
Como aquí en Semana Santa:
Dos rosquillas y un mamón.
 Y en fin, marcharán en bola
Y sin guardar distinción,
Toditos los artesanos
Con rumbo para el panteón.
 Y después de tanta facha
Y de tantas peloteras,
Serán todos un montón
De peladas calaveras.

Propiedad particular.—Imprenta de Antonio Vanegas Arroyo Calle de Santa Teresa, número 1.—México

Impresor Infortunado,

Con tu buen *componedor*
Y tu *original* ileso,
Le pegas muy recio al *hueso*
Como especial parador.
Cual *calavera* de honor
Paraste mucho *breviario*,
Hiciste gran calendario
De todas las calaveras,
Y amontonaste *galeras*
Hasta dentro el campanario,

Joyero sin Piedras.

Todas las hermosas lloran
Al ver tu sentida muerte,
Lo mismo el débil y el fuerte
Triste situación deploran.
Contemplando se demoran
Los que obtuvieron de ti
Los diamantes, el rubí,
Y las piedras más preciosas,
Por eso muy lastimosas
Ven tu calavera aquí.

Latonero del Cabildo.

Aquí yacen los restos
De un latonero
Que por ser buen tornero
Torneó á los muertos.
Allá en sus desaciertos
Torneó metales
Y ahora tornea los huesos
De los mortales.
Vengan las calaveras
Vivas en cuellos
Verán como las deja
Sin un cabello.

Maquinista Descompuesto.

Mil máquinas de vapor
Hizo este sublime artista,
No hubo un sólo maquinista
Que le fuera superior.
Con la medalla de honor
Premió el mundo su instrucción,
Y con gran veneración
Y en una rica litera,
Llevaron su calavera
A enterrarla en el panteón.

Notario Público.

Entre las mil escrituras.
Hiciste grandes contratos,
Y con variados relatos
Hipotecas las más puras.
Con el premio y las usuras,
Enarbolaste bandera
Y por Dios! quién lo creyera
Que haciendo tan buen servicio,
Un día te llamara á juicio
Haciéndote calavera.

Oculista Atrevido,

Curaste muy bien los ojos
De los tuertos y los ciegos,
Y por infinitos ruegos
Cumpliste necios antojos.
Ahora te plantan de hinojos
Ante tu fosa una flor,
Pidiéndole al gran Criador
Perdone tu mal manera,
Porque fuiste un calavera,
Un calavera de honor.

Pintor de Patos.

Fuiste excelente pintor,
Pintaste varias figuras,
Exquisitas hermosuras
Dignas de elogio y de honor.
Como pintor, grande fama
Adquiriste, así te llama
Todo el mundo por doquiera
Pues te nombra calavera,
Quien su porvenir espera
Y su pintura reclama.

Químico sin Vale.

En química sabio fuiste
Porque nadie te igualó,
Y muy clarito se vió
Que tu fama siempre existe.
Tú con honor adquiriste
La gloria imperecedera,
Porque fuere lo que fuera
Hiciste tu medicina,
Mas hoy el mundo destina
Que seas triste calavera.

Rebocero Averiguador.

Tú hiciste muy buena trama
En rebozos de bolita
Y una figura exquisita
Que te conquistó la fama,
Por eso el mundo te llama,
Tejedor en gran esfera.
Porque con tu lanzadera
Hiciste de lo mejor,
Por eso con gran honor
Veneran tu calavera.

Sastre sin Medida.

Tú hiciste muy buenos trajes
Los cortastes á la moda,
Para los hombres de toda
Costumbre en usos de viaje.
Cortaste á todo el linaje
Pantalones, calzoneras,
Con botón y con ojeras
Y dejaste aquí en la historia
Para más grata memoria,
A tus clientes *calaveras*.

Tapicero san Lunero.

Una casa tapizaste
Con tal lujo y tal grandeza,
Que no se igualó belleza
Que para igualarla baste.
Ella hiciera un gran contraste
En tapiz de mal manera,
Más si consiguiente fuera
En hablar pura verdad,
Dirías con sinceridad:
Murió y fué á ser calavera.

Urdidor sin Pensamiento.

Este fué buen urdidor
En las telas de rebozos.
En los zarapes lanosos,
Y en las mantas fué mejor.
Fué exelente tejedor,
Hizo sus devanaderas,
Co perfección de deveras
Por su buena condición,
Pero después fué al panteón
A unirse á las *calaveras*.

Vaquero Desmañanado.

Fué tu destino ordeñar,
Y fué tu suerte tan flaca,
Que siempre al pie de la vaca
Te pudimos contemplar.
Teniendo que madrugar
Te madrugó á tí la muerte,
Y sin poder detenerte
De esa señora tan fiera,
Nos dejas tu calavera
Que no hay ojos con que ver

Xochitl desenbridora del Neutli

Xochitl la indígena hermosa
Mil laureles conquistó,
Pues el rey la enamoró
Mirándola tan preciosa.
Una jícara espumosa.
De néctar ofreció al rey,
En buena y no en mala ley,
Con una amistad sincera,
Por eso una calavera
Plantaron en su maguey.

Yesero de agua Cola.

Muchos muñecos de yeso
Hizo este pobre italiano,
Más su esfuerzo salió vano
Porque no hizo gran progreso
Y mirándose por eso
En tan mala condición,
Se marchó á la otra región
A hacer nuevas esculturas,
Y entre otras tantas figuras
Calaveras del panteón.

Zapatero de mala Horma.

Un zapatero afamado
Muchas glorias conquistó,
Pero nunca se le vió,
Con platas al desgraciado.
Tiempre triste y arrancado
Se le veía por doquiera
Esta fué su triste esfera,
Y por la misma razón,
Los hombres en el panteón
Contemplan su calavera.

Súplica interesante á los vivientes

En la conmemoración
de vuestros fieles difuntos.
os suplican todos juntos,
pidais por su salvación.
Profunda meditación,
una salve y un rosario,
cual sufragio extraordinario,
todos los días una misa.
Es lo que más nos precisa,
que no falte en el santuario.

Que hacen vuestros amigos y parientes

Los que venis al panteón
debeis pensar con acierto,
que el hombre después de muerto
aspira su salvación.
Mirad nuestra conclusión
y así rogadle por nos,
porque de la muerte en pos
vamos todos en seguida,
y que nuestra mala vida
hoy nos la perdone Dios.

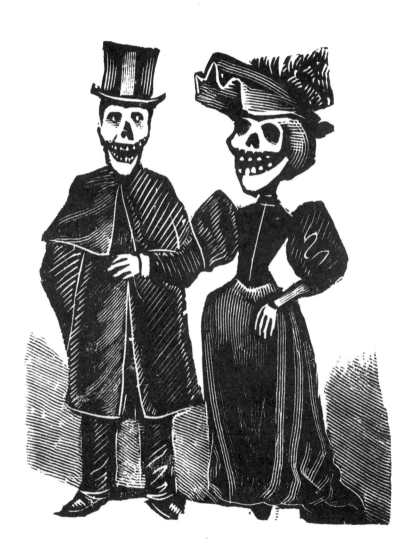

Opposite José Guadalupe Posada, Day of the Dead *calavera*
with verses for various professions, 1890–1913
Above José Guadalupe Posada, Elegant skeleton couple from
The Great Cemetery of Love, 1880–1910

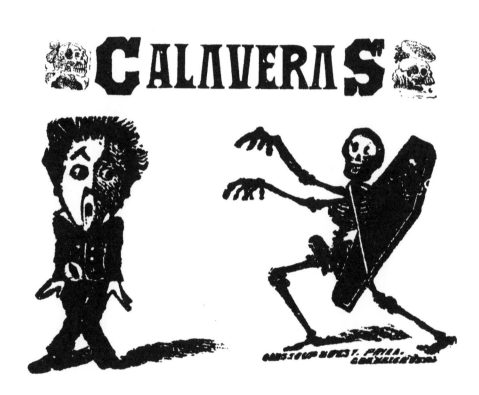

Above José Guadalupe Posada, Day of the Dead figures, 1890–1910
Opposite *The Great Skeleton Dance*, 1890–1910

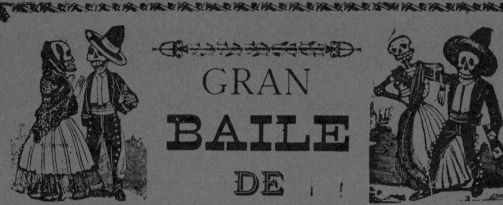
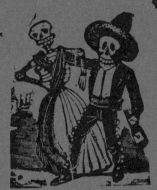

GRAN
BAILE
DE
CALAVERAS.

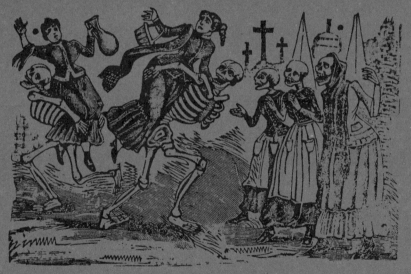

Llegó la gran ocasión
De divertirse deveras,
Van á hacer las calaveras
Su fiesta en el Panteón.

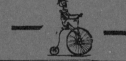

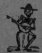

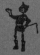

Las tumbas se han adornado,
Los sepulcros se han barrido,
Los féretros se han pulido
Y las lozas barnizado.

Los festejos sepulcrales,
Muchas horas durarán;
Los muertos asistirán
Con vestidos especiales.

Con gran anticipación
Calaveras y esqueletos
Se han hecho trajes completos
Que luzcan en la reunión.

México, Imprenta de Antonio Vanegas Arroyo Calle de Santa Teresa núm. 1 — 1906.

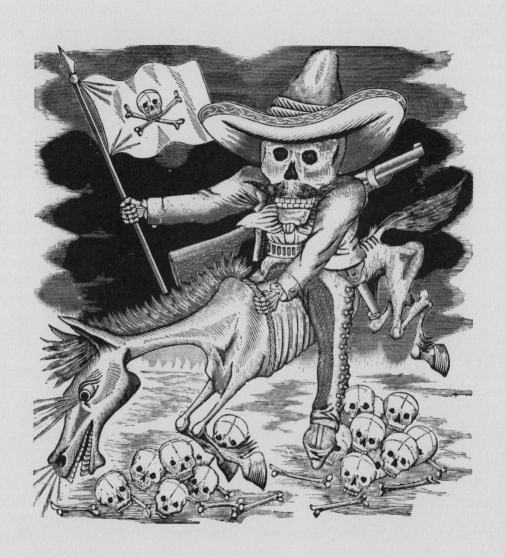

REVOLUTIONARY SONGS

"La Valentina," by an unknown composer, is one of many Mexican ballads (*corridos*) celebrating courage in the face of death. It dates from the Mexican Revolution, and was probably inspired in 1914 or 1915 by the Revolutionary fighter Valentina Ramírez. Jorge Negrete sang the song in the film *La Valentina* (1938). The last two lines have become a catchphrase in Mexico.

Valentina, Valentina,	Valentina, Valentina
yo te quisiera decir	I long to tell you
que una pasión me domina	the passion that governs me
y es la que me hizo venir	compelled me to come
Dicen que por tus amores	Because of your love
La vida mi han de quitar	they will kill me, I'm told
No le hace que sean muy hombres	I don't care how brave they are
Yo también me sé pelear	I too know how to fight
Si porque tomo tequila	Today I drink tequila
mañana tomo jerez,	tomorrow I'll drink sherry
si porque me ves borracho	if today you see me drunk
mañana ya no me ves	tomorrow you won't see me at all
Valentina, Valentina,	Valentina, Valentina
rendido estoy a tus pies,	I bow down at your feet
si me han de matar mañana	If they're going to kill me tomorrow
que me maten de una vez.	let them kill me right away.

Opposite José Guadalupe Posada, *¡Gran Calavera de Emiliano Zapata!*, 1910–13

José Guadalupe Posada, *This is Don Quixote's First and Matchless Giant Calavera*, c.1910

SERGEI EISENSTEIN
¡QUÉ VIVA MÉXICO!

"In Mexico the paths of life and death intersect in a visual way, as they do nowhere else; this meeting is inherent both with the tragic image of death trampling on life, and with the sumptuous image of life triumphing over death ... The overlapping of birth and death ... is visible at each step – in the cradle which is glimpsed in every sarcophagus, the rosebush growing at the summit of the crumbling pyramid, or in the fatal words that appear, half erased, on a sculpted skull: 'I was like you, you will be like me.' ... At every step, life and death fuse constantly; so too do appearance and disappearance, death and birth. On the Day of the Dead, even small children stuff themselves with crystallized sugar skulls and chocolate coffins, and amuse themselves with toys in the form of skeletons ... November the 2nd, 'Death Day,' is given over to irresistible mockery of death ..."

Extract from Eisenstein's memoirs. Since they were written in 1946, his autobiographical writings have been edited and published in different forms, both censored and uncensored.

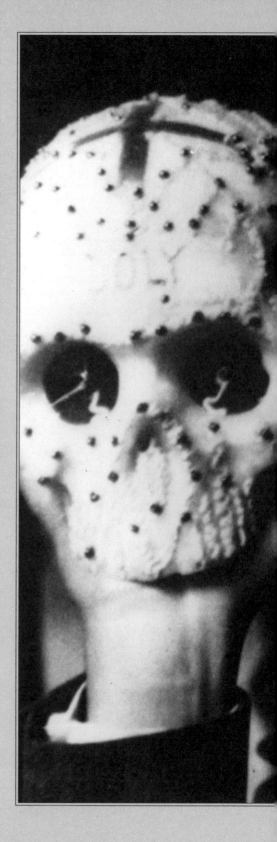

Agustín Jiménez, Sergei Eisenstein in Mexico with a sugar skull, 1931

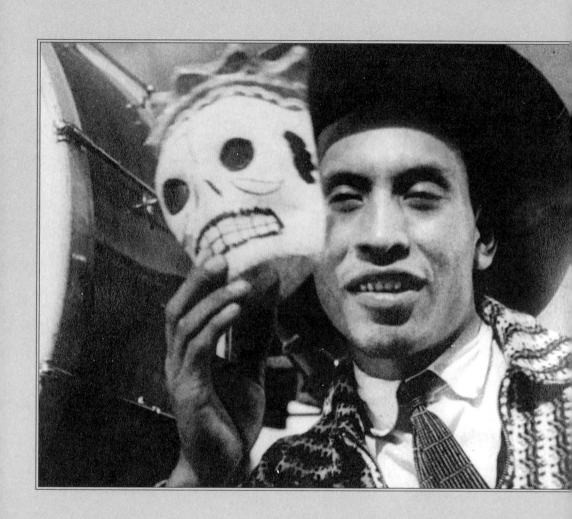

Above and opposite Stills from *Death Day*,
shot by Sergei Eisenstein in 1931 and released as a short film in 1934

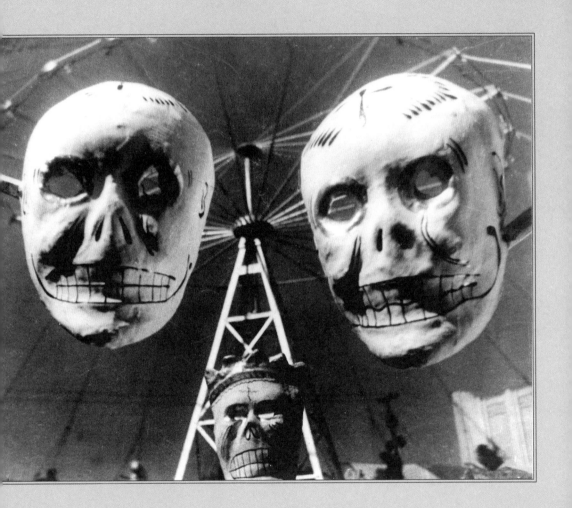

Overleaf Still from *¡Qué Viva México!*, shot in Mexico by Sergei Eisenstein in 1931

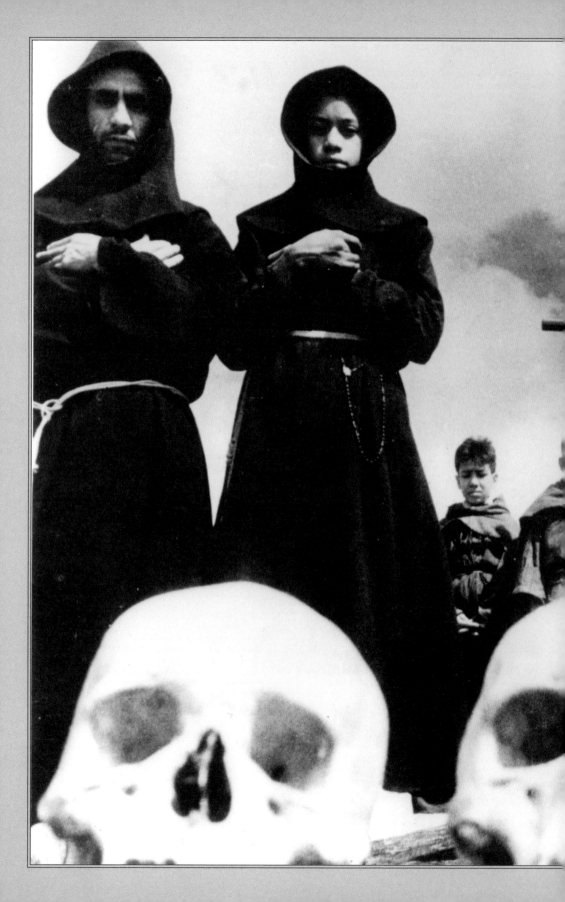

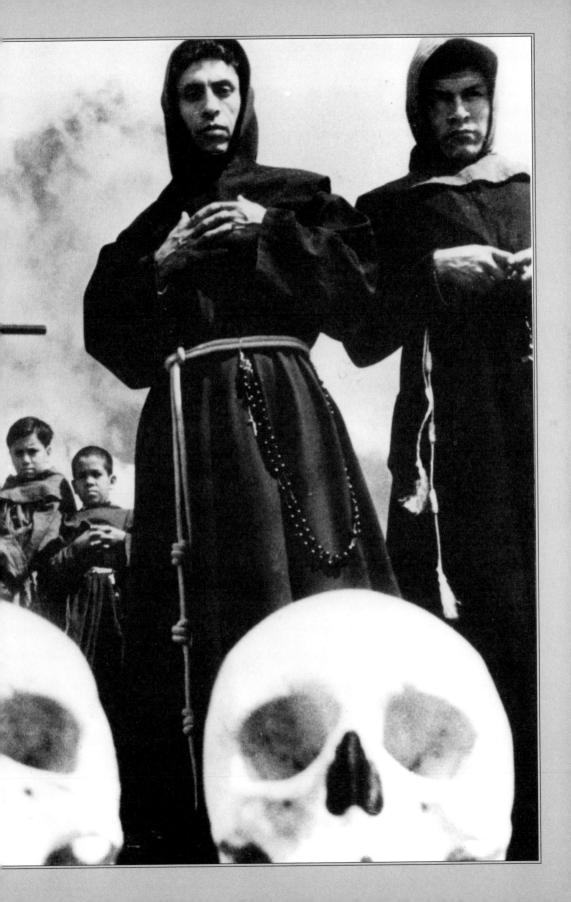

MEXICAN POPULAR SONGS

Mexican songbooks contain a large number of *corridos* (popular ballads) dominated by sadness and fatalism. Often by unknown composers, and inspired by war and combat, they celebrate courage in the face of danger. "Clarín de Campaña" dates from the Mexican-American War of 1846–48, after the annexation of Texas by the United States.

Viene la muerte luciendo
mil llamativos colores
ven dame un beso pelona
que ando huérfano de amores

Death comes radiant
in a thousand eye-catching colors
come give me a kiss bald one
I am in need of love

El mundo es una arenita
y el sol es otra chispita
y a mi me encuentran tomando
con la muerte y ella invita.

The world is a grain of sand
and the sun is but a spark
here I am drinking
and I'm Death's guest

No le temo a la muerte
mas le temo a la vida
como cuesta morirse
cuando el alma anda herida.

I have no fear of Death
I have more fear of Life
how bitter it is to die
when the soul is wounded.

Se va la muerte cantando
Por entre las nopaleras
En que quedamos pelona
Me llevas o no me llevas?

Death goes singing
between the nopales (prickly pears)
what have we decided, bald one,
will you or won't you take me?

Tomás Méndez Sosa (composer and singer, 1927–1995).
His song "La Muerte" has been recorded by many famous singers,
including Antonio Aguilar and Francisco El Charro Avitia

CLARÍN DE CAMPAÑA

Mientras tengan licor las botellas,
hagamos con ellas
más dulce el vivir

Recordando que tal vez mañana
clarín de campaña
nos llame a morir

Mientras tengan perfume las flores
olviden dolores
y vengan a amar

Recordando que tal vez mañana
clarín de campaña
nos llame a pelear

Mira Muerte, no seas inhumana
No vengas mañana,
déjame vivir

Recordando que tal vez mañana
Clarín de campaña
nos llame a pelear.

Todos dicen que el cuerpo es de tierra,
que el alma que encierra
es lo que ha de vivir

Recordando que tal vez mañana
clarín de campaña
nos llame a morir

Vengan, vengan, muchachas hermosas,
venid presurosas,
que vengan a amar

Recordando que tal vez mañana
Clarín de campaña
nos llame a pelar.

THE CAMPAIGN BUGLE

While we have wine in our bottles
let us drink
and make our lives sweeter

For tomorrow
the bugle may sound for battle
and call us to die

While the flowers have perfume
let us forget suffering
and give ourselves to love

For tomorrow
the bugle may sound for battle
and call us to fight

Listen Death—don't be inhuman
stay away tomorrow,
and let me live

For tomorrow
the bugle may sound for battle
and call us to fight

Everyone says the body is but earth,
that the soul it contains
is what will endure

For tomorrow
the bugle may sound for battle
and call us to die

So come to us, pretty girls,
come in haste,
and give us love

For tomorrow
the bugle may sound for battle
and call on us to fight.

Unknown author, 1847

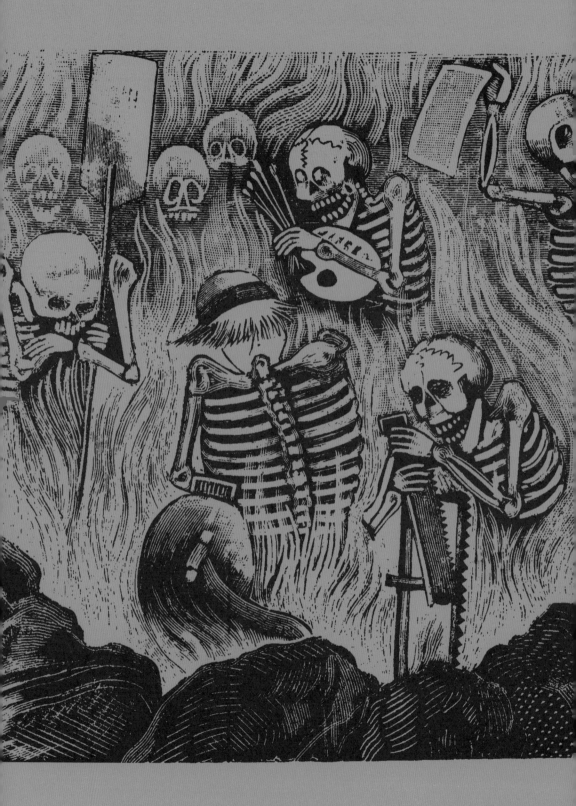

José Guadalupe Posada, *Purgatory of the Arts where the Skeletons of Artists and Artisans Lie*, 1890–1913

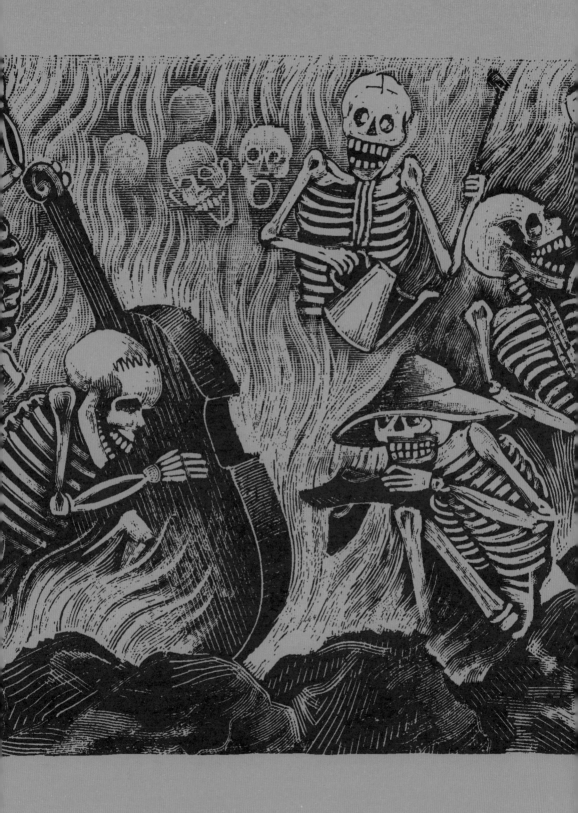

EL GRAN PANTEON AMOROSO.

Leed, pues, este Panteón de los Amores Y hallaréis muchos gustos y dolores
Todos los que habitáis aquí en la tierra, Que el gran secreto de la tumba encierra.

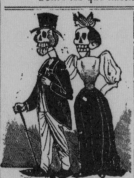

Aquí van con sus amores
Gozando dos calaveras:
La que en vida fué Dolores,
Y él de apellido Contreras.

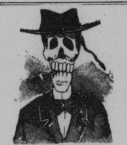

Aquí yace un buen torero,
Que murió de la aflicción
De ser mal banderillero,
Silbado en cada función;
Ha muerto de un revolcón
Que recibió en la trasera,
Y era tanta su tontera
Que en el sepulcro ya estaba
Y á los muertos los toreaba
Convertido en calavera.

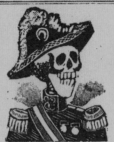

General que fué de suerte
Y mil acciones ganó
Y sólo una la perdió
La que tuvo con la muerte;
Nadie hay que al mirarle acierte
Si fué un sabio ó de tontera,
Hoy es una calavera
Con gorro en verdad montado,
Y aunque esté condecorado
Hoy ya no es lo que antes era.

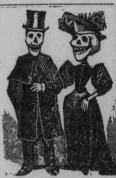

Aquí tienen á dos muertos,
Tal cual para cada quien,
Casados por desaciertos,
Paseando y vistiendo bien.

—¿Usted no sabe de amores?
—A según cuando conviene.
—¿Quiere ir conmigo á Dolores?
—Charrito, si aquí me tiene.

—Adios; no ande de celoso,
—Me cree con los ojos tuertos.
—Si alguno me hiciera el oso
Se contaba entre los muertos.

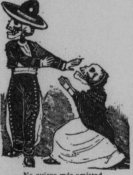

—No quiero más amistad.
—Mi amor no ha sido quimera.
—Dejadme en la soledad
Y en paz, torpe calavera.

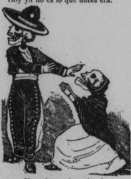

Y aquel charrito celoso
Pudo al fin tragar el queso,
Y con su muerte afanoso
Marchóse á llorar el hueso.

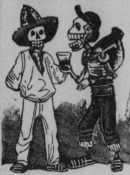

—Métale á la penca, vale.
—Atórele á los ardores.
—Ojas; pero no me jale.
—Pos vamos para Dolores.

No he visto mujer más fina
Pa cantar una canción
Ni en toditito el Japón
Ni en toditita la China,
Pues canta la muy índina
Con tal aire y tal sal salero,
Que no hay en el mundo entero
Quien cante bien sus amores,
Como ésta que ví en Dolores
Junto á un sepulcro ratero.

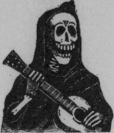

No me eche una rata muerta
Vestida de colorado,
El muerto chino taimado
Que me ha espiado ya la puerta;
Mi calavera no es tuerta,
Y si canto sin quimera
Es hoy por la vez postrera,
Pues pronto la muerte flaca
Ya mero mis restos saca
Y á Dios de mi calavera.

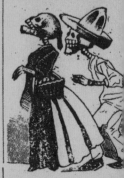

—Con tal de llorar el hueso
Con usted, preciosa güera,
Me va á dar pa copa y queso
Por muerto y por calavera.

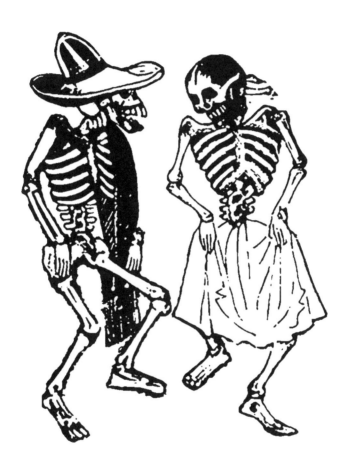

Opposite José Guadalupe Posada, *The Great Cemetery of Love*, 1880–1910
Above José Guadalupe Posada, from *The Wheedling Ways of Flirtatious Waitresses*, c.1910

Above Manuel Manilla, *The Infernal Skeleton*, 1882–92
Opposite Manuel Manilla, Wrestling match, 1882–92

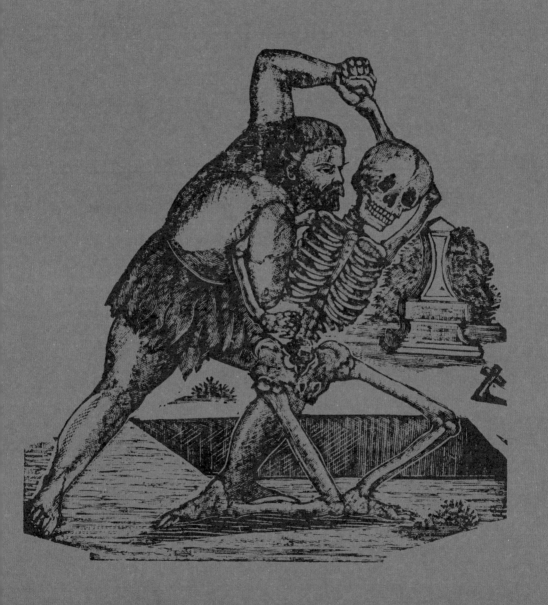

DE ESTE FAMOSO HIPODROMO EN LA PISTA
NO FALTARA NI UN SOLO PERIODISTA.

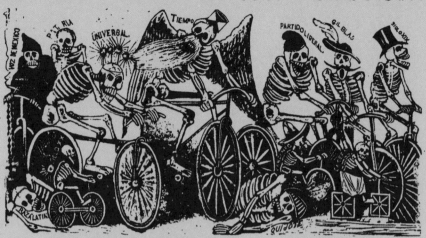

LA MUERTE INEXORABLE NO RESPETA
NI A LOS QUE VEIS AQUI EN BICICLETA.

El Demócrata Salió de
por Belém se fué á pasear,
y allí dejó el inocente
por siempre de respirar.
Ya no volverá á pelear
como tenía de costumbre,
pues por meterse á la lumbre
hasta la vida perdió,
y hoy se halla en la podredumbre
del panteón en que cayó.

De El Tiempo, ni la guadaña
pudo escapar á la guerra,
que la muerte hizo en la tierra
con encarnizada saña.
Su destreza no fué extraña
para salir bien librado,
pero siempre fué alcanzado
por la muerte en su carrera,
y llegó á ser calavera
y un esqueleto pelado.

Con tajos y bandolones
El Fandango festejado
aun viéndose en los panteones
quiere quedar en reposo.
Siempre alegre y bullicioso
se dá á la podre Cuaresma
cada revolución que zumba,
pues que ni en la misma tumba
dejará de ser tronera.

Dos Quince, sin pensar
en tan negra desventura,
en profunda sepultura
y en una fúnebre lugar.
Y en tan fúnebre lugar
no partió su valentía,
y combate noche y día
esgrimiendo con pujanza,
la aguda y terrible lanza
que es para el de gran valía.

Por calavera, Gil Blas,
murió y murió derrepente,
al saber que apareció
en su contra el Solo Vivo.
No hay duda que fué valiente
de la prensa en la gran lucha,
pero no era de cachucha,
y quiso ser tronera,
y aunque su suerte fué mucha
se volvió al fin calavera.

El Partido Liberal,
que se reía de este mundo,
no contaba con la muerte
ni con un fin funeral.
Pero de esa ley fatal
no pudo libre mirarse,
y tuvo que restaurarse
murmurando con dolor,
sin que pudiera escaparse
ni el gran Martín Pescador.

Y El Fandanguín que vió
en mala época á este mundo,
aunque con dolor profundo
cumplió también la misión.
No teniendo ni un potino
para correr á retreta,
marchó en una bicicleta
caminito del panteón,
decidido, y con razón
á volverse anacoreta.

Por combatir, El Combate
en la lucha pereció,
y aunque ya muerto, no halló
quien en valor se le empate.
No hubo quien le diera mate
más que la pelona fiera,
que le dejó calavera
sin guardarle cumplimiento,
pues que no se anda con tientos
para llevarse á cualquiera.

Y El Siglo Veinte murió
aunque á su pesar por cierto,
que gran éxito alcanzó
antes de llorarse muerto.
Y al morirse medio yerto
cuando soñó ser atleta,
montó en una bicicleta
para ganar la carrera,
queriendo por esta treta
escapar la calavera.

La Voz de México, atenta
á salmodiar el rosario,
machucándose á la cuenta
se fué veloz al osario.
Allí un salmo funerario
entona con voz doliente,
quedando prudentemente
lejos de la pelotera,
que armará esta calavera
en todo el mundo viviente.

Por meterse á fandero
del periodismo en la liza,
se quedó hasta sin camisa
la pobrecita Cámara.
Convertida en calavera
y con su llave cargando,
va de prisa caminando
pues con afán se figura,
que en la misma sepultura
podrá seguir enredando.

Murió El Imparcial también
que más hubiera vivido,
si á pasear no hubiera ido
por las puertas de Belém.
Allí le entró un requiem
un grupo de periodistas,
que lloraban sus conquistas
con lágrimas como nueces,
maldiciendo los reveses
de ser tan calaveritas.

 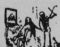

Falleció El Diario Oficial
en una catastrófica,
porque puso en ridículo
su carrera profesional.

La Sombra de Juárez fué
como sombra, convertida
en nube desvanecida
que se evaporó también.

Y aquel México moribundo
que tanta guerra nos dió,
padeció del callejón
de una indigestión de timbre.

No te vanaglories El Mundo
Político, no es en balde
pues hoy se ha dado al azúcar
con todito tu cabal.

Ya del Mundo Vistoso
ni las orejas quedaron,
porque con ellas cargaron
dos perros y un aguador.

El Hijo del Ahuizote
por una carambola
que armó un tren a la muerte
fué á dar á la sepultura.

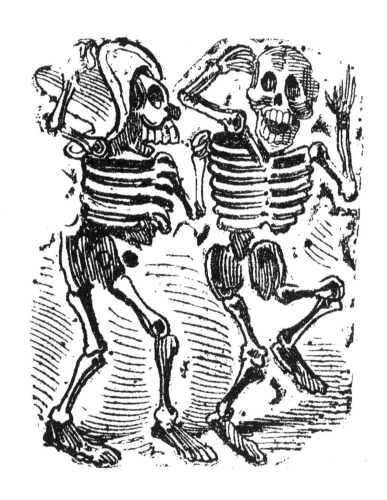

Opposite and above José Guadalupe Posada, *Calaveras*, c.1900

FRIDA KAHLO

Frida Kahlo (1907–1954) was admired
for her exuberance and gaiety. Her last
painting, done shortly before her death,
was a still life of watermelons: the words
Viva la Vida (Long Live Life) decorate their
crimson surface. Yet Kahlo's love of life was
sorely tested. She survived polio as a child
and a devastating road accident as a teenager.
In later life, housebound and sometimes
bedbound, she endured chronic pain and
a succession of medical procedures. Kahlo's
intense preoccupation with mortality was
reflected in her art. The threat of her own
early death was a key factor, but Kahlo
identified strongly with Mexican popular
culture and its acceptance of death.
Pre- Hispanic stone skulls, prints by Posada,
pottery skeletons, and sugar skulls (some
decorated with her own name) were
flamboyantly displayed in the house she
shared with her husband, Diego Rivera.

In Kahlo's painting *El Sueño* (The Dream),
death is entwined with sleep and dreams.
As in real life, a gigantic papier-mâché
skeleton reclines on the canopy of the
artist's bed. Made originally for Holy Week,
this Judas figure transforms her bed into
a double-level tomb. *Niña con máscara de
calavera* (Girl with Death Mask) shows a
small girl, probably Frida Kahlo herself,
wearing a papier-mâché mask and holding
a marigold flower for the Day of the Dead.
Both paintings evoke an ancient duality:
death is the bearer of life, while birth is the
cradle of death.

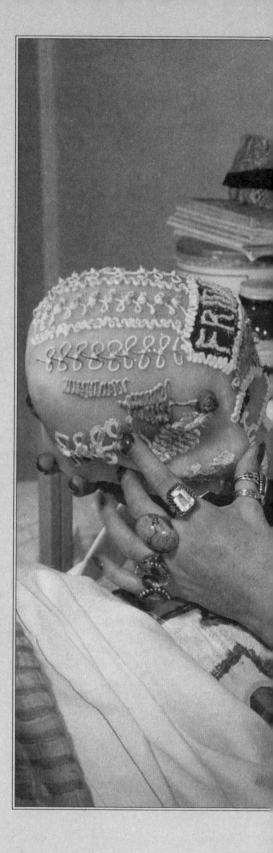

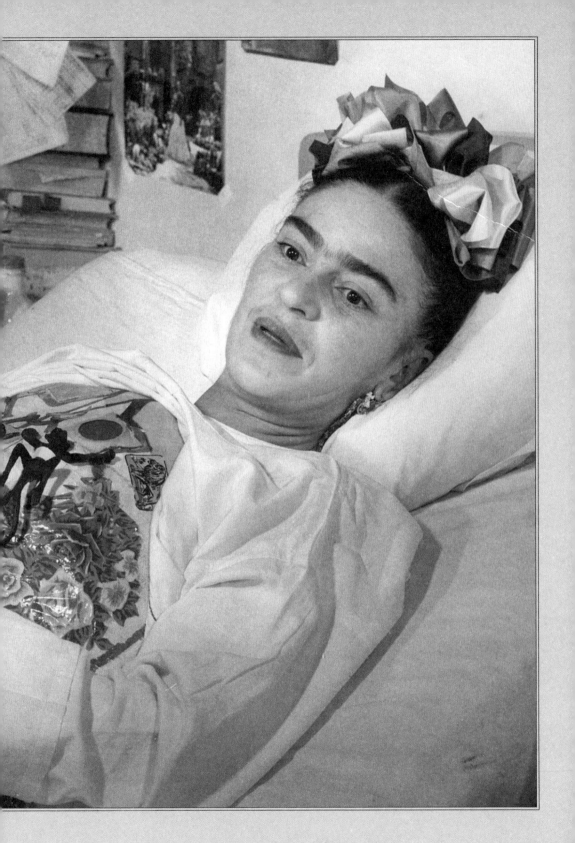

Juan Guzmán, Frida Kahlo with a sugar skull during her year-long stay
at the English Hospital in Mexico City, 1950

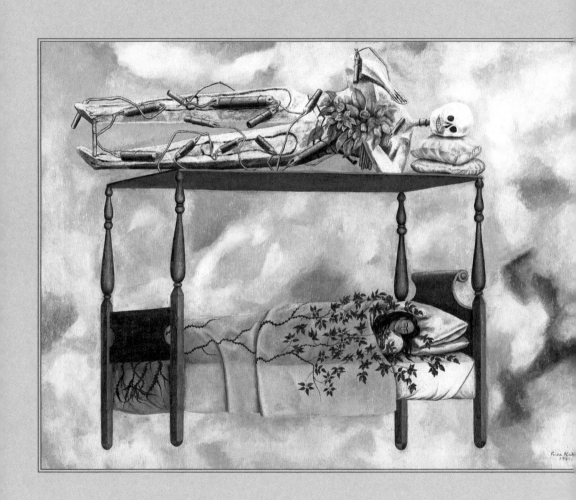

Above Frida Kahlo, *The Dream*, 1940
Opposite Frida Kahlo, *Girl with Death Mask*, 1938

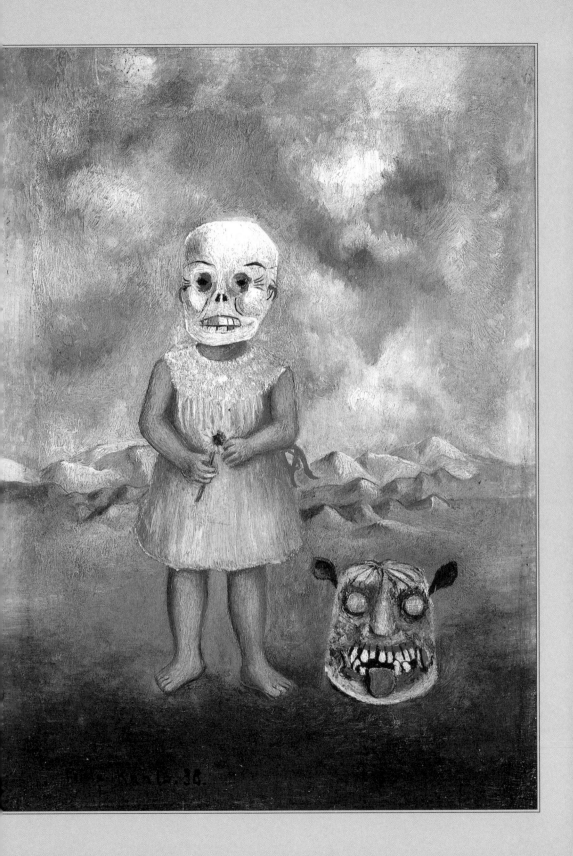

2

THE DAYS
OF THE DEAD:
CELEBRATING MEMORY

All human societies find ways to remember their dead.

In Mexico, during *Los Días de Muertos* (Days of the Dead), the living honor the departed with lavish offerings in homes and cemeteries. The festival, perhaps the most important in the Mexican calendar, is a complex event with roots that go far back in time. The cultural fusion has been so complete that it would be difficult to determine today which aspects of the festival were introduced from Christian Europe and which existed previously as part of the Indigenous cult of the dead. Although the festival varies from region to region, it is always regarded as a time of reunion, remembrance, and renewal. For a brief period, the living join together with relatives and friends to welcome back the souls of the departed on their yearly visit to Earth.

As mid-October approaches, markets fill with foodstuffs, cooking vessels, and decorative items for home altars. Although the graves of loved ones are tended throughout the year, families now visit cemeteries to tidy and redecorate. Some graves in rural areas are highly personalized (see page 83). Throughout Mexico, the dead are commemorated on November 1 and 2 (All Saints' Day and All Souls' Day), but observances start earlier in many regions. *Ninín* is the name given by the Totonac, who live near Papantla in the state of Veracruz, to their long cycle of festivities, which start on October 18 (the feast of St. Luke) and end on November 30 (the feast of St. Andrew). Local custom in many communities dedicates October 28 to *los accidentados* (those who die in accidents), October 29 to *los ahogados* (those who die by drowning), and October 30 to *los limbos* (unbaptized infants). The souls of dead children, known as *angelitos* (little angels), are widely thought to arrive on October 31, and the souls of dead adults on November 1. Their arrival is often announced by noisy volleys of locally made fireworks.

Pathways of flower petals, scattered outside and inside the home, guide the deceased to the waiting *ofrenda* (offering). Flowers are a key element, and the Mexican marigold, known by its Náhuatl name *cempasúchil*, predominates. With its brilliant-yellow coloring and pungent odor, it has long been associated with death. Other offerings include *copal* (incense), candles, salt and water, soft drinks, fruit, and figures made from bread or sugar. These are set out on the domestic altar—usually a table on which holy pictures and statues of Catholic saints are arranged.

If families have photographs of the deceased —many do not—these are displayed among the offerings. The souls of dead children are given *comida blanca* (white food), lovingly prepared without chili and served in diminutive dishes. Spicy foodstuffs are reserved for the adult dead, who may also receive alcohol and cigarettes. Sometimes these offerings are accompanied by gifts of clothing or work tools. Many families also create a small altar outside the home for *las ánimas solas*—forgotten souls with no one to care for them. After the souls have extracted the "essence" from these offerings, the sweet breads and other foods are shared by the living.

While some home altars are fairly simple, others are vast and costly constructions. The style depends on the financial resources of the family and on regional tradition. In the state of Veracruz, where home altars are visually splendid, it is usual to have two: one for the saints and one for the souls. Representations of skulls and skeletons—whether they take the form of sugar figures, toys, or paper cut-outs—are shunned in many rural communities. In San Pablito in the state of Puebla, for example, Otomí villagers say that their inclusion would offend the souls.

Home altars are the creation of each individual family and can vary considerably. In Huaquechula in the state of Puebla, however, those who have died during the preceding year are honored in spectacular manner by professional altar-builders. Over a structure of tables, wooden boxes, and planks, approximately 250 feet of white satin are draped and pinned into pleats and ruches. These elaborate, ceiling-high constructions for the "new dead" incorporate a profusion of flowers, both fresh and artificial, holy images, and ornaments of various kinds. These include plaster angels and *llorones* (weeping children).

Eugenio Reyes Eustaquio (overleaf) works as a carpenter throughout the year. During the month of October, however, he and his team of helpers work tirelessly in the homes of the bereaved. They are paid for their time, but also for their inventiveness and skill. Eugenio explains: "Each *ofrenda* is unique because of the way it is decorated; the white material symbolizes purity. Although altars vary, they all have three levels. One must show the Earth, where we ourselves live. Next comes the separation: the physical from the spiritual. And lastly heaven. These three levels define each altar." Although the outlay is considerable, the living shoulder the financial burden without hesitation. Not taking into account the food and drink offered to visitors, the total cost of a finished altar reached 15,000 pesos ($730) in 2019. (An unskilled worker, meanwhile, earned an average of 120 pesos [$6] per day.) Eugenio says, "Here in Huaquechula, we go to enormous effort and make many sacrifices to receive *los fieles difuntos* (the faithful departed). This is our custom, as believers. This tradition has become like a law for us."

Festivities usually end on November 2, when the living gather in cemeteries across Mexico to say a fond farewell to loved ones. Graves are colorfully decked out with flowers and greenery. Sometimes there is music and even dancing. *Xantolo* dancers in the Huasteca region of Hidalgo perform in the cemetery and in the courtyards of people's homes. In the central valleys of Oaxaca, dancers may perform in village streets and squares. Night-long vigils are customary in the state of Michoacán, while daytime vigils are preferred in most other regions. When *Los Días de Muertos* draw to a close, most celebrants feel comforted and happy. According to the celebrated weaver Crispina Navarro Gómez, who lives in the village of Santo Tomás Jalieza in the state of Oaxaca, "We take flowers to the graves of our departed on November 2. When the bells sound at noon, we know they are leaving us. We feel at peace, and those who are leaving must surely feel tranquil too. We have made them welcome, and they see that we are well."

In its traditional form, the Mexican festival of the dead has little in common with Halloween. According to believers, the dead return in peace, not as ghouls or spooks. As Crispina explains, the living are unable to see or hear the dead. Silent and invisible visitors from the afterlife, they return each year to share the pleasures of the living. Images of Christian saints have replaced the old gods, but celebrations convey a sense of timelessness.

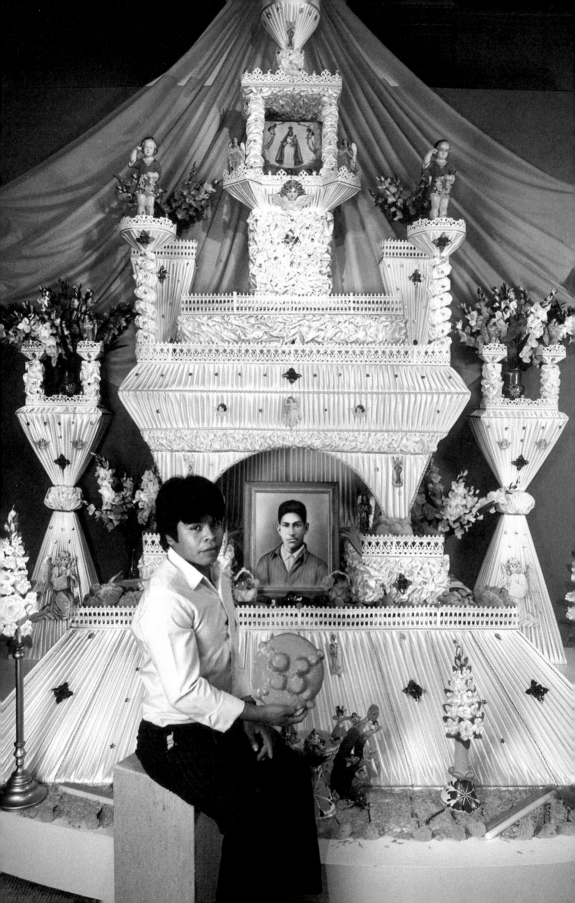

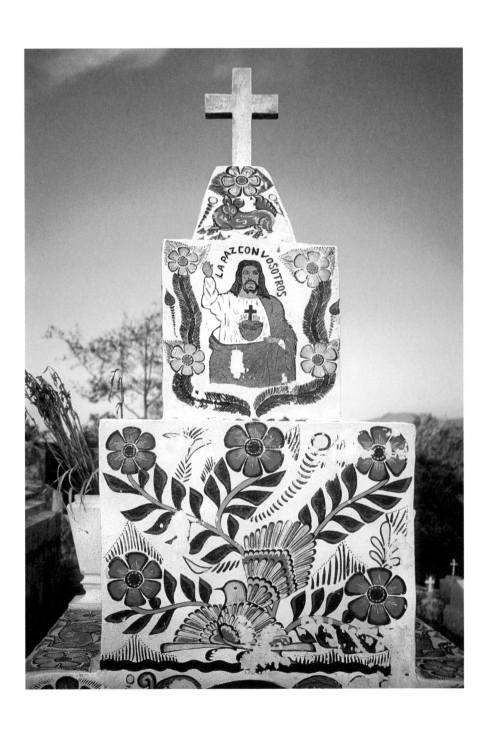

Opposite Eugenio Reyes Eustaquio from Huaquechula, Puebla,
with a satin-covered altar for the "new dead," 1991
Above Child's painted grave in the Otomí village of San Pablito, Puebla, 1990s

Above Breadseller with *pan de muerto* (bread for the dead), Puebla City market, 2011
Opposite Children in the cemetery in Huaquechula, Puebla, 2009

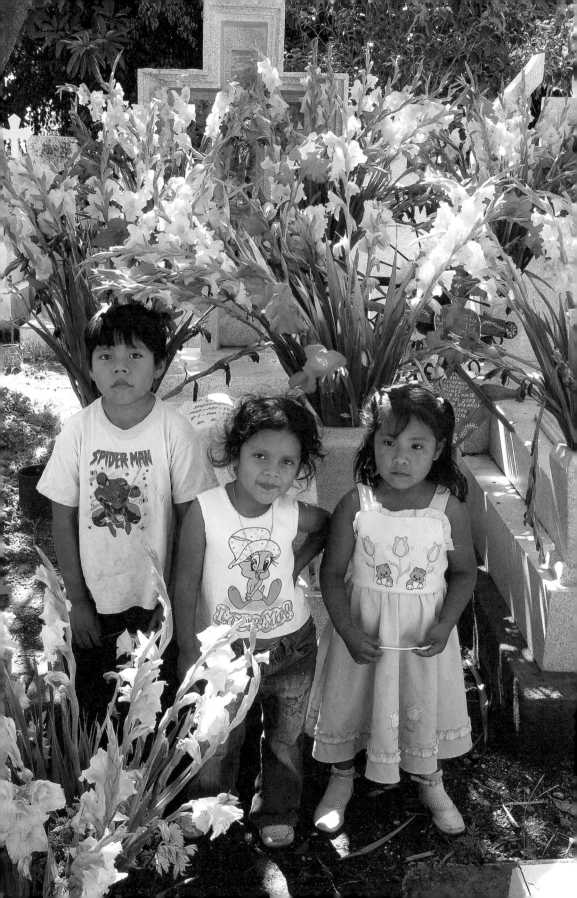

*El mexicano … la frecuenta, la burla,
la acaricia, duerme con ella, la festeja,
es uno de sus juguetes favoritos
y su amor más permanente.*

**"The Mexican ... is familiar with [death],
jokes about it, caresses it, sleeps with it,
celebrates it; it is one of his favorite
toys and his most steadfast love."**

Octavio Paz, *El laberinto de la soledad* (*The Labyrinth of Solitude*), 1950

Opposite Dancers celebrating on All Saints' Day,
San Bartolo Coyotepec, Oaxaca, 2019

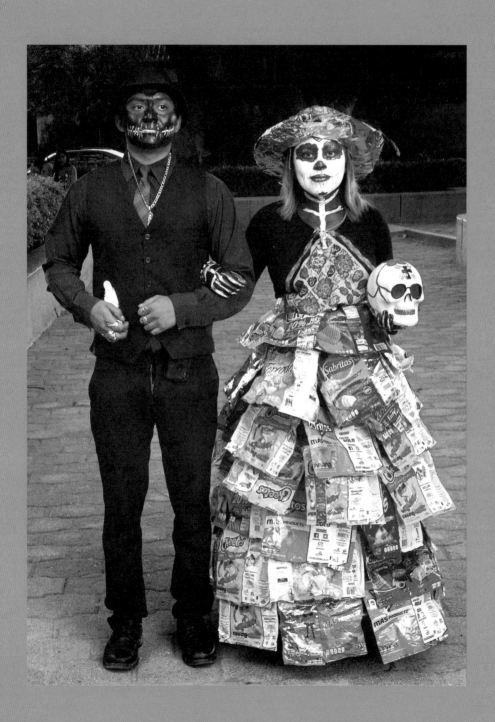

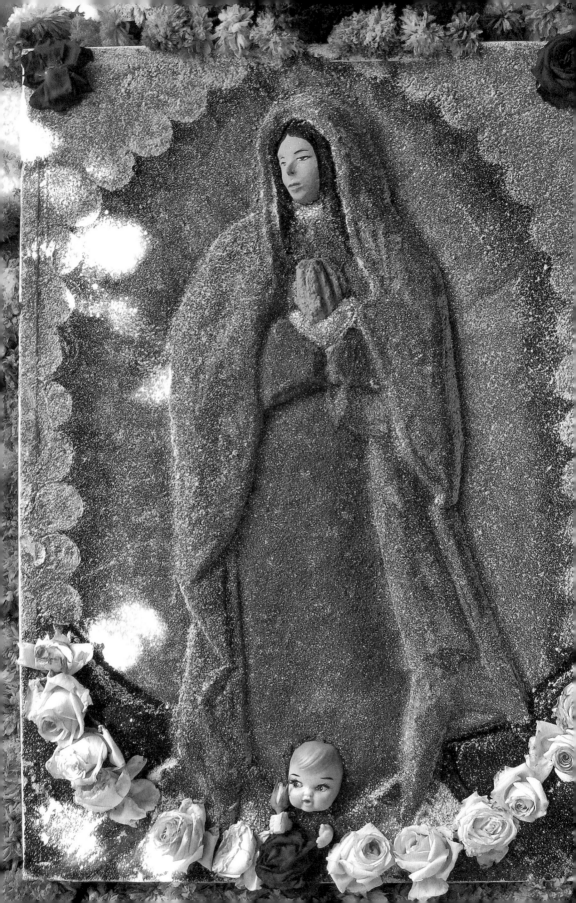

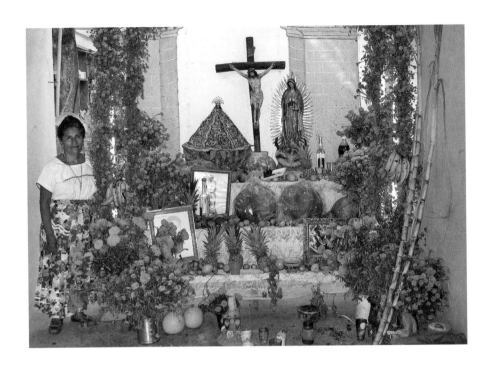

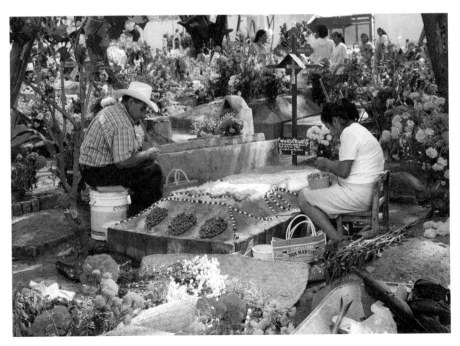

Opposite Sand picture of Our Lady of Guadalupe made by
Angélica Delfina Vásquez Cruz, Santa María Atzompa, Oaxaca, 2017
Top Ceramicist Irene Aguilar Alcántara with her *ofrenda* in Ocotlán de Morelos, Oaxaca, 2011
Above Decorating graves in the cemetery of San Antonino Castillo Velasco, Oaxaca, 2001

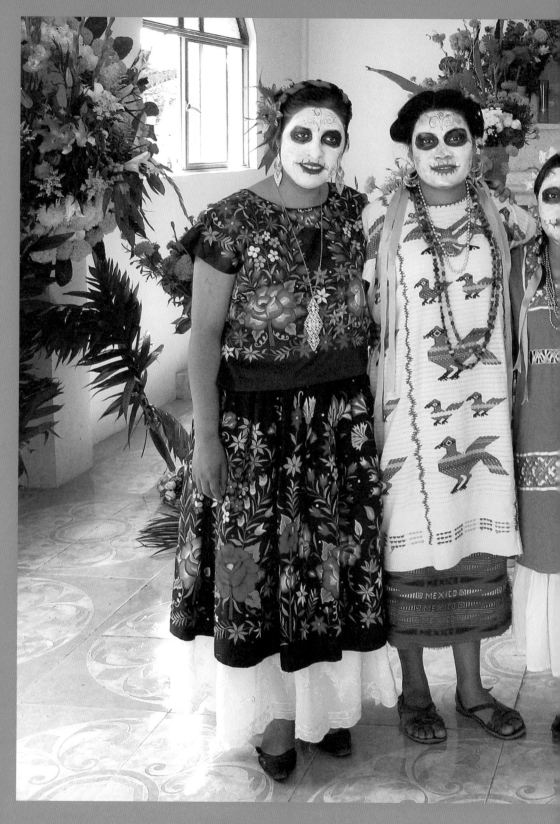

Celebrants in the cemetery chapel,
San Antonino Castillo Velasco, Oaxaca, 2011

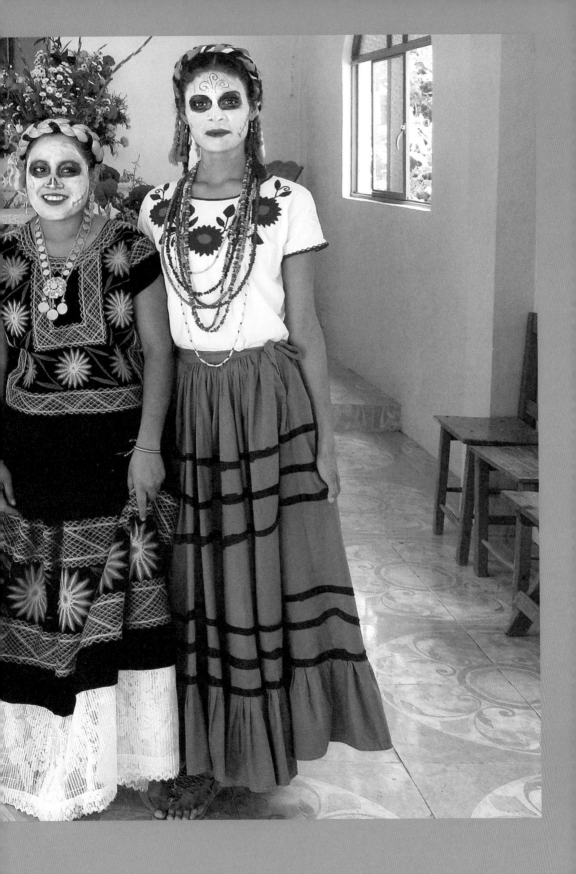

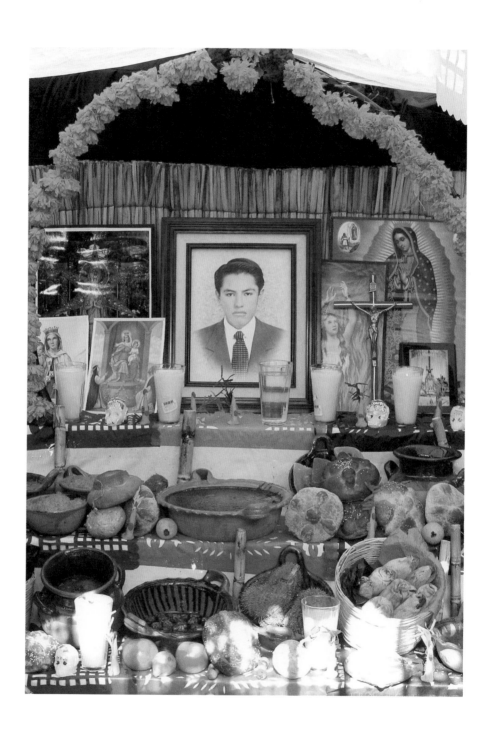

Above Traditional *ofrenda*, Tlaxcala City, 2011
Opposite Commemorative plaque from 1908 in the cathedral courtyard, Campeche City

MEXICAN TERMS
FOR DYING

Colgó los tenis
He hung up his sneakers

Ya está en el otro lado
He's on the other side

**Se puso la pijama
de madera**
He put on his
wooden pajamas

Huele a tierra
He smells of earth

Se lo cargó la huesuda
The Bony One
carried him off

Estiró la pata
He stretched out
his legs

Se petateó
He lay down on his
sleeping mat

Se fue al otro barrio
He moved to the
other neighborhood

Se nos adelantó
He went on ahead

Colgó los guantes
He hung up his gloves

Se peló
He lost his hair

Escupió el chicle
He spat out his
chewing gum

Ya se lo llevó la flaca
The Thin Lady
has taken him

Devolvió el envase
He gave back the
packaging

Ha dejado de fumar
He stopped smoking

Entregó el equipo
He gave back his
equipment

Ponerse el traje de palo
To wear one's wooden suit

**Mirar las plantas
desde abajo**
To gaze at the
plants from below

Tiró la toalla
He threw away
his towel

**Ya se le fundió
el chip**
His "chip" burned out

**Va a doblar
la servilleta**
He's folding up
his napkin

**Se lo llevó
la pelona**
The Bald Lady
has taken him

Se subió a la azotea
He's gone up to the
roof terrace

Pasó a mejor vida
He's gone to a better life

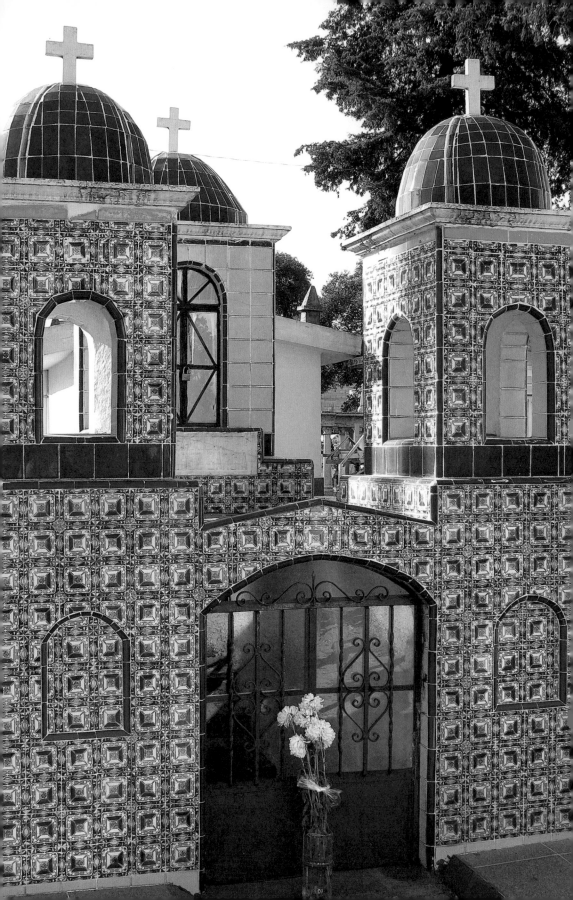

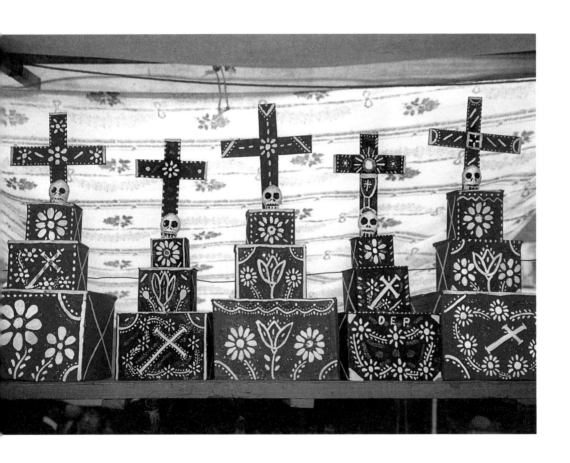

Opposite Tiled tomb built to resemble a church, Metepec cemetery, State of Mexico, 2019
Above Papier-mâché catafalques on sale before the Day of the Dead, Oaxaca City, 2001

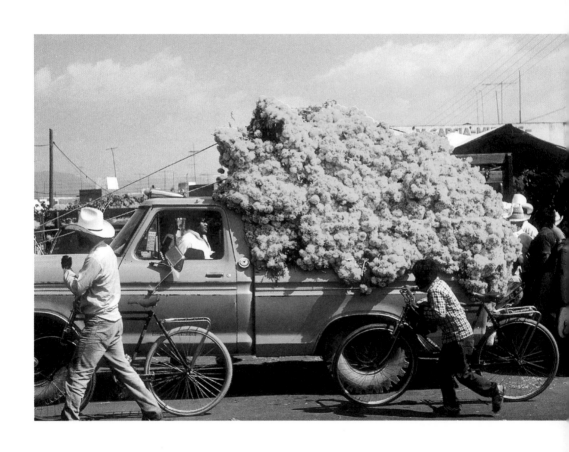

Above Marigolds arriving in the market in Atlixco, Puebla, 1980s
Opposite Girls selling marigolds and cockscomb to welcome the souls, Puebla City, 2011

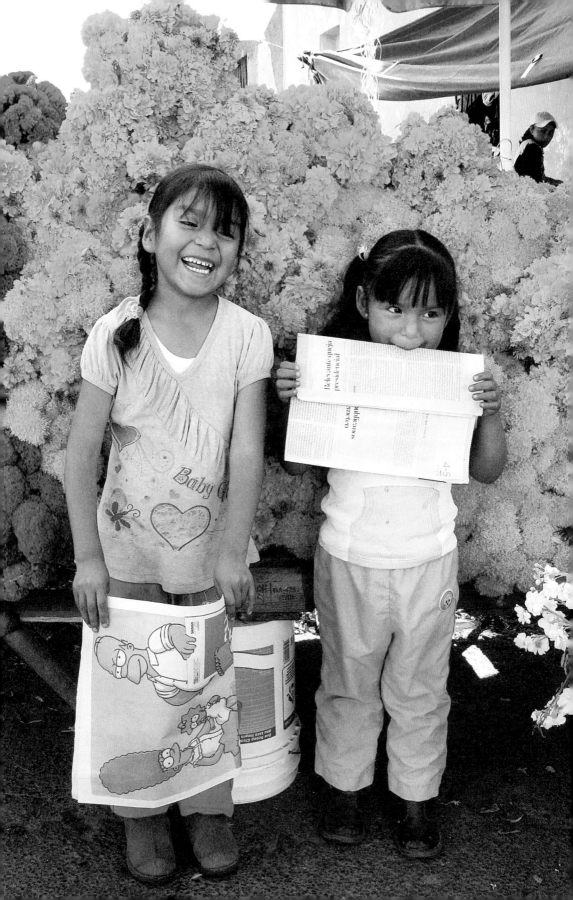

Nada en este mundo dura
fenecen bienes y males
y a todos nos hace iguales
una triste sepultura.

Nothing endures in this world
good and bad things pass away
and a sad sepulcher
makes all of us equal.

Day of the Dead verse (anonymous)

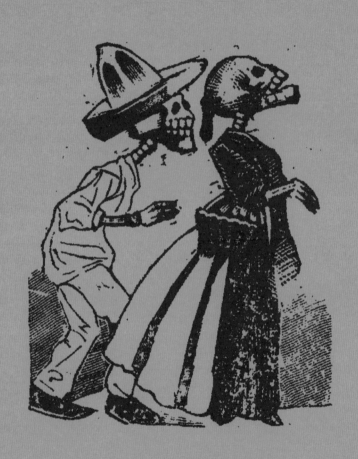

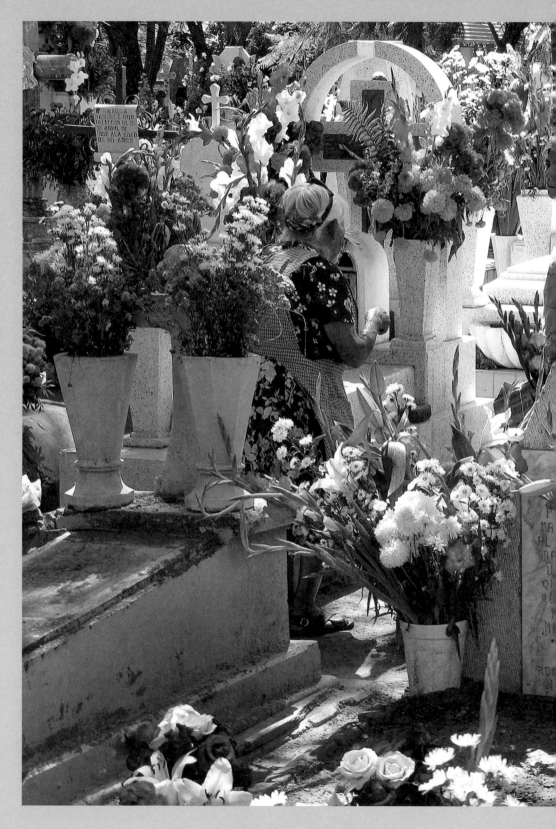

Accompanying the souls in the cemetery of
San Antonino Castillo Velasco, Oaxaca, 2011

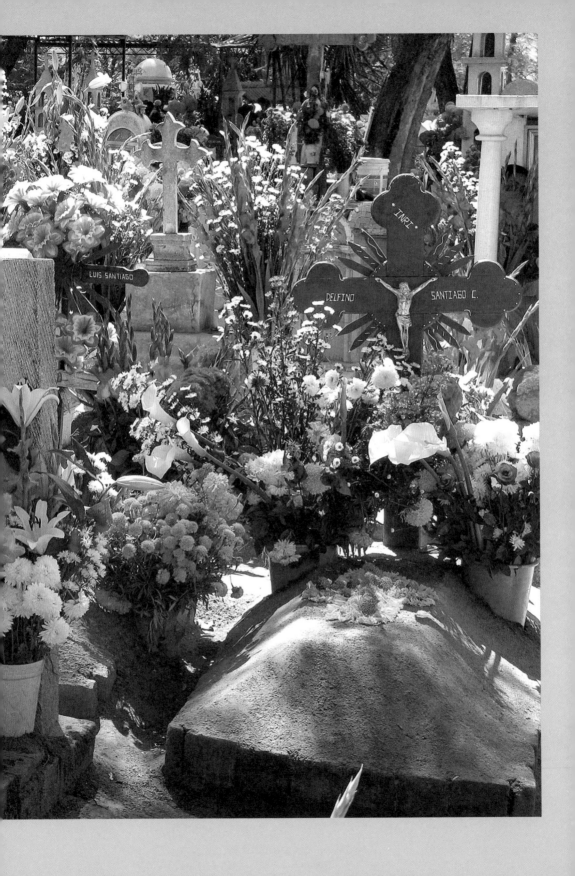

DIEGO RIVERA

After the Mexican Revolution, muralism was promoted by the state as a way of shaping national identity. Diego Rivera (1886–1957) returned to Mexico in 1921, after a fourteen-year absence and a successful European career. Back in the land of his birth, at the age of 35, he forged his own art style and found his subject matter. Later, he described this awakening as a rebirth: "My homecoming produced an aesthetic exhilaration which it is impossible to describe... It was as if I were being born anew, born into a new world... In everything I saw a potential masterpiece—the crowds, the markets, the festivals...."

Rivera's frescoes for the Secretaría de Educación Pública (Ministry of Public Education) reveal his enthusiasm for the Indigenous cultures and regional traditions of Mexico. In the rear courtyard, he evoked different types of fiesta. *La Ofrenda* (The Offering) shows an all-night graveside vigil in the state of Michoacán. On November 1, as dusk falls, cemeteries near Lake Pátzcuaro fill with Purépecha villagers carrying candles and ceramic incense-burners. Tombs are elaborately decorated with marigolds. Beautiful and ephemeral, they symbolize life's fragility. The accompanying fresco, *Día de Muertos* (Day of the Dead), shows exuberant celebrations in racially diverse Mexico City. Then, as now, urban festivities are marked by the sale of sugar skulls and by displays of papier-mâché masks and skeletons.

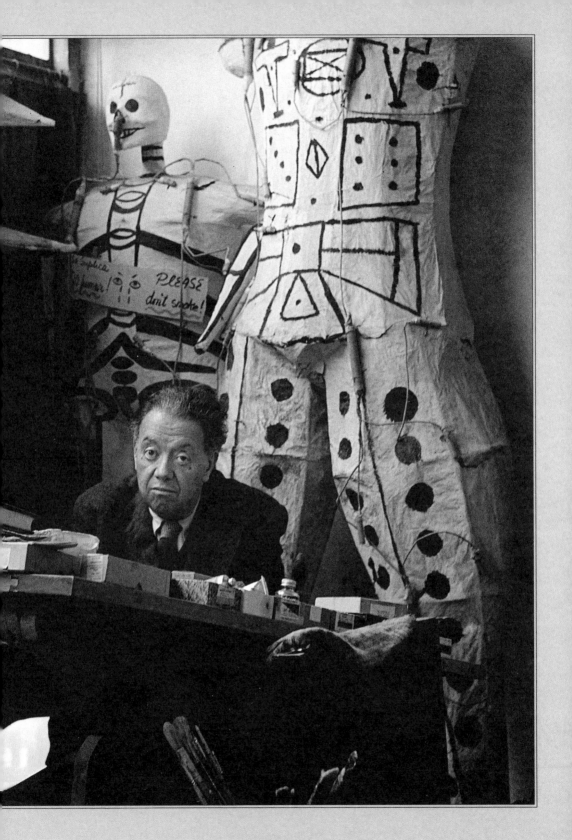

Gisèle Freund, Diego Rivera in his studio with gigantic
papier-mâché Judas figures, Mexico City, 1951

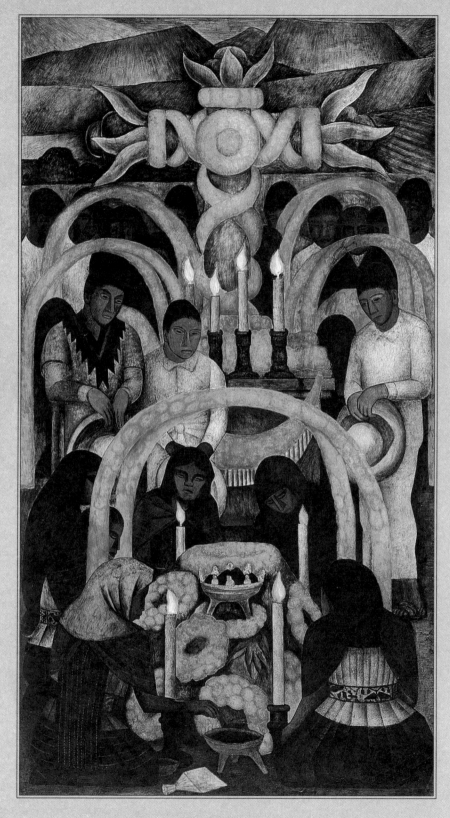

Above Diego Rivera, *The Offering*, 1923
Opposite Diego Rivera, *Day of the Dead*, 1924

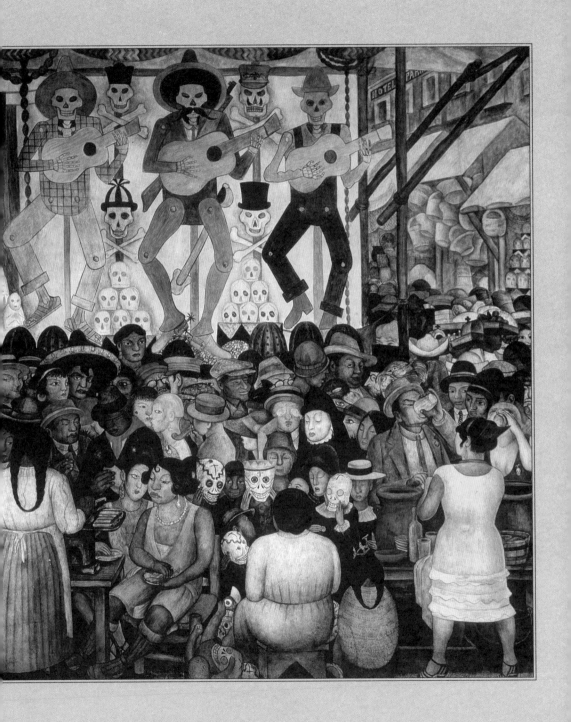

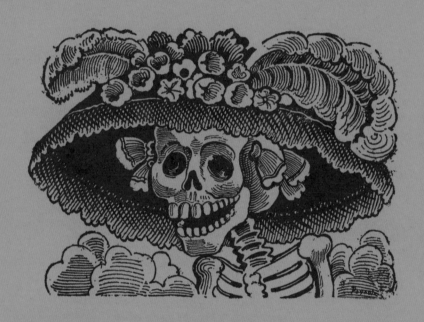

3

LA CATRINA

The image of La Catrina is known the world over.

In Mexico she has become a national symbol, as instantly recognizable as Emiliano Zapata and other heroic figures from history. Yet this iconic female skeleton originated as a skull in a popular print. Wearing a large feathered hat above gaping eye sockets and bony shoulders, she was created between 1910 and early 1913 by the engraver José Guadalupe Posada in his popular *calaveras*.

La Calavera Garbancera poked fun at servant girls and working women who pretended to be of a higher class. Flaunting heeled slippers and corsets, they wore the finery of the bourgeoisie, even if it meant going hungry or selling purloined spoons. Like their mistresses, who hoped to pass as European, they wore pale makeup to disguise their Indigenous heritage. A *catrina* is the female counterpart of the *catrín* or dandy. Foolish and vain, the girls described in *La Calavera Garbancera* display their charms (*se la echan de catrinas*), yet all are destined for the grave. Like the *memento mori* of medieval Europe, where the skull reminded viewers of their own mortality, Posada's engraving stressed the transience of earthly pleasures. Death is the great equalizer.

La Catrina's next incarnation occurred in 1946–7, when the Mexican muralist Diego Rivera painted *Dream of a Sunday Afternoon in the Alameda Central* (pages 122–3). This vast mural, commissioned for the Hotel del Prado in Mexico City, depicted key figures from the panorama of Mexican history. After the earthquake of 1985, it was given its own museum. La Catrina, positioned in the center of the mural, is transformed from a figure of fun into a woman of elegance. Attired in the style of the Porfirian era (1876–1911, when Porfirio Díaz was president), she wears her broad-brimmed hat with a full-length dress and a serpent-headed feather boa. This is a visual reference to the pre-Hispanic god Quetzalcoatl, the plumed serpent. Rivera portrays himself as a schoolboy holding La Catrina's bony hand. Behind him stands his wife, the artist Frida Kahlo. Also included in this surreal scene is Posada, wearing the dark suit and solemn expression that we know from photographs (see page 37).

Rivera's now famous mural gave La Catrina a body. Importantly, it also gave her an identity that resonates down the decades.

Today, La Catrina is flamboyantly rendered in every imaginable medium, including clay, sugar, papier-mâché, bone, and wood. Colorful cut-out paper banners show her full figure or present her as a skull. Tinsmiths and miniaturists pair her with a male partner. Public offerings, dedicated to the souls of the departed, incorporate images of La Catrina made from dyed sawdust, flower petals, and dried seeds. Thus, from her roots as a critique of social pretension, she now represents death itself. Since *la muerte* (death) is a feminine noun in Spanish, La Catrina is ideally suited to this role. In Europe, death was traditionally visualized as a male figure—the "grim reaper" carrying a scythe or an hourglass. La Catrina, in her feather boa and Porfirian finery, is an altogether more festive presence. Mexican communities in the USA love to celebrate her: like the Virgin of Guadalupe, La Catrina has become a familiar figure in murals and posters across Los Angeles and San Francisco. Even computer animators have used her as inspiration for the character of La Muerte, in films such as *The Book of Life* (2014) and *Coco* (2017).

In recent years, La Catrina has even become a figure of flesh and blood. Buskers and street performers take on her appearance; parades and processions adopt her as their lead character; glamorous young women at nightclubs and private parties offer a seductive and celebratory version of La Catrina. Her most interesting physical incarnation, however, was devised by the Mexican artist Humberto Spíndola (b.1950). In 2007, he was invited to stage an art performance for the Museo Mural Diego Rivera in Mexico City. A Mexican actress, wearing an elegant ensemble fashioned by Spíndola from white tissue paper, appeared to step from Rivera's mural. She greeted the audience and the cameras, and offered a satirical commentary on the modern era. When Spíndola was subsequently invited to restage this dramatized event in different countries, he used a painted reproduction of the mural's central scene.

More than a century has passed since the publication of *La Calavera Garbancera*. Over time, as the photographs in this chapter show, Posada's most famous creation has achieved an identity that is all her own. She has transcended the critical perspective of the original broadside to become a revered and much-loved symbol of cultural pride for Mexicans everywhere.

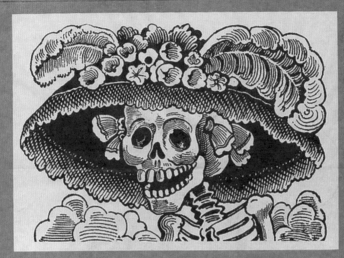

LA SRIA. DE EDUCACION, DIR. GRAL. DE EDUCACION ESTETICA
presenta
del 7 de abril al 7 de junio de 1943,
EN HOMENAJE A LA MEMORIA DEL GENIAL GRABADOR MEXICANO

JOSE GUADALUPE
POSADA
la
EXPOSICION
de su obra en el
PALACIO de BELLAS ARTES

Mexican poster for an exhibition of work by
José Guadalupe Posada, 1943

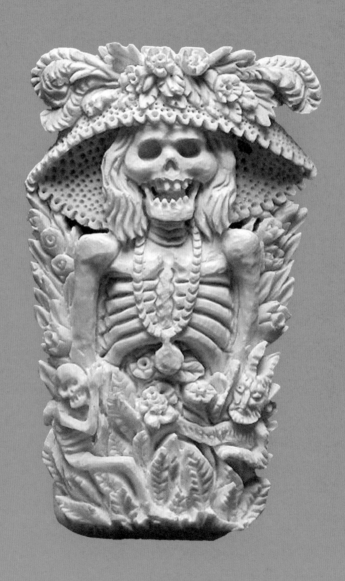

Do you not hear the mournful knell
Nor heed the message of that bell?
Your breathless hurry's only waste:
You cannot win for all your haste.
Soon on the last bed where you lie,
The beauty gone from arm and thigh,
How then can you meet your lover
With only bare bones left to offer?

19th-century Mexican verse (anonymous)

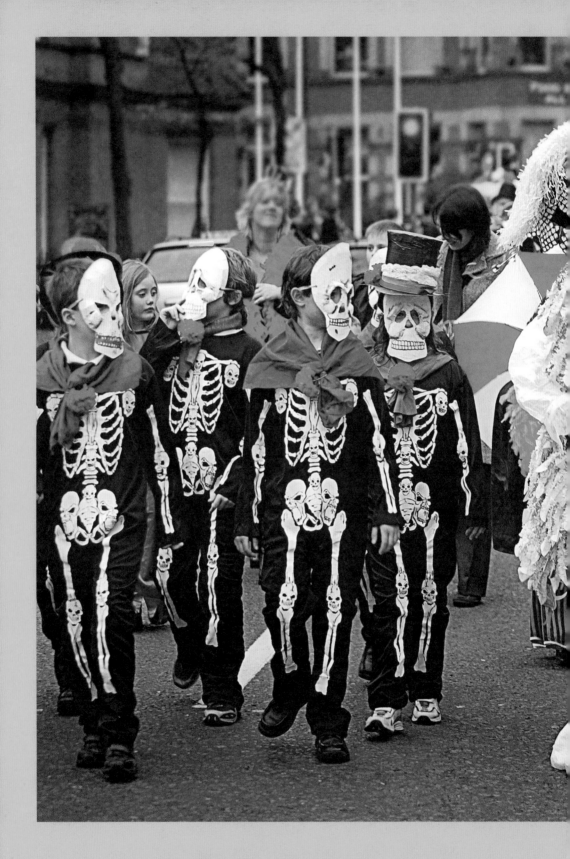

Procession led by La Catrina, choreographed by Humberto Spíndola, Belfast, 2004

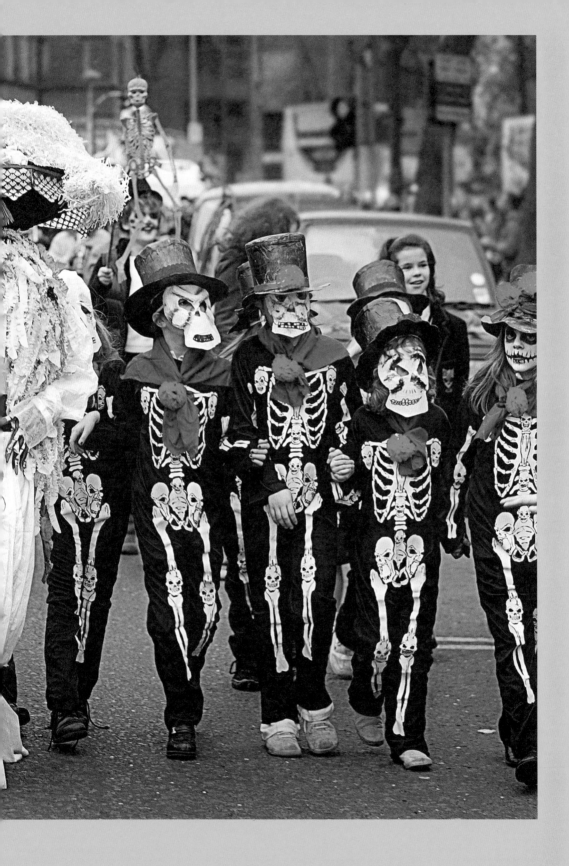

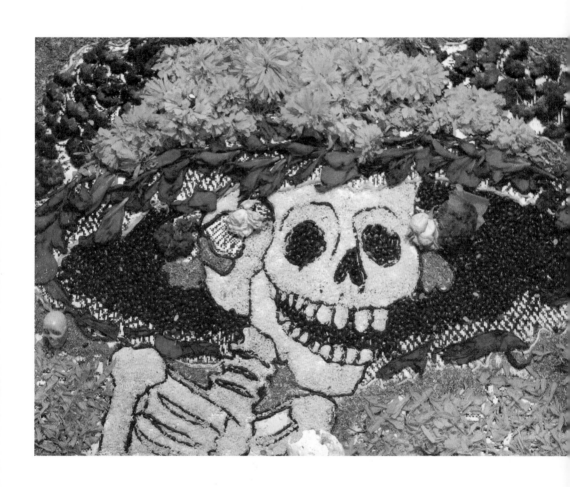

Above La Catrina represented with rice grains and flowers for an *ofrenda*, Puebla City, 2011
Opposite Maurilio Rojas, Paper banner showing La Catrina from San Salvador Huixcolotla, Puebla, 1991

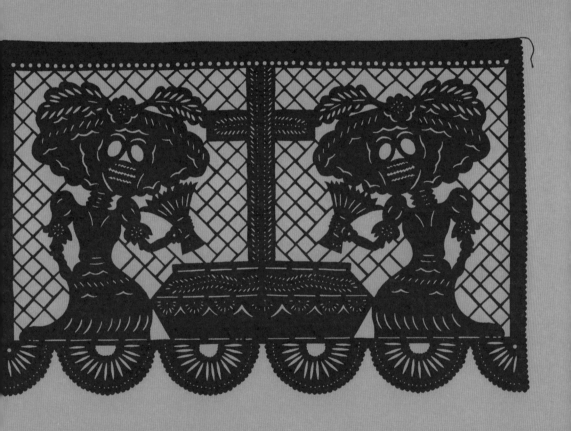

REMATE DE CALAVERAS ALEGRES
— Y SANDUNGUERAS —

Las que hoy son empolvadas GARBANCERAS, pararán en deformes calaveras.

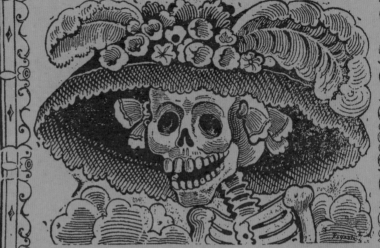

Hay hermosas garbanceras,
De corsé y alto tacón;
Pero han de ser calaveras,
Calaveras del montón.

Gata quete pintas chapas
Con ladrillo o bermellón:
La muerte dirá: «No escapas,
«Eres cráneo del montón.»

Un exámen voy a hacer,
Con gran justificación.
Y en él han de aparecer
Muchos cráneos del montón.

Hay unas gatas ingratas,
Muy llenas de presunción
Y matreras como ratas,
Que compran joyas baratas
En las ventas de ocasión.

A veces se llaman «Rita»,
Otras se llaman «Consuelo»,
Y á otras les dicen «Pepita»;
A esas la muerte les grita:
«No se duerman, que yo velo;
«Y en llegando la ocasión,
«Que no mucho ha de tardar,
«Heridas por un torzón,
«Calaveras del montón.
«Al hoyo iréis a parar.»

Hay unas «Rosas» fragantes,
Porque compran «Pachulí»
Unas «Trinis» trigarantes.
Y unas «Choles» palpitantes,
Dulces como un pirulí;
Pero también la pelona
Les dice sin emoción.
«No olviden a mi persona,
«Que les guarda una corona
«De muelas en el panteón.

Vienen luego las mañosas
Que «Conchas» se hacen llamar,
Y que aunque sean pretenciosas,
No tienen perlas preciosas,
Sino magre hasta más dar.

A éstas y a las Filomenas,
Que usan vestido zancón
Y andan de algodón rellenas,
Las ha de acabar sus penas
La Flaca con su azadón.

Siguen las Petras airosas,
Las Clotildes y Manuelas,
Que puercas y mantecosas.
Son flojas y pingajosas
Y rompen muchas cazuelas.
La enlutada misteriosa,
Que impera allá en el panteón.
Y es algo cavilosa,
Con su guadaña filosa
Las echará al socavón.

Las Adelaidas traidoras,
Que aparentan emoción
Si oyen frases seductoras,
Y que son estafadoras
Y muy flojas de pilón;
Se han de ver próximamente.
Sin poderlo remediar,
Sumidas enteramente
En el hoyo pestilente
De donde no han de escapar.

Las Enriquetas melosas,
Unidas a las Julianas
Y a las Virginias tramposas,
Que compran baratas cosas,
Aunque resulten mal sanas;
Pagarán su picudéz
Y sus mañas de agiotista,
Sumiéndose en la estrechez
Y en la inmunda tobreguez
Porque la muerte es muy lista.

Las pulidas Carolinas,
Que se van a platicar
En la tienda y las esquinas,
Y se echan de catrinas
Porque se saben peinar:

Han de dejar sin excusa
Los listones y el crepé,
Y en un hoyo cual de tusa.
Se hundirán con todo y blusa,
Con choclos y con corsé.

Las Marcelas y las Saras,
Que al Cine van a gozar,
Vendiendo hasta las cucharas,
Y se embadurnan las caras
Porque pretenden gustar,
Serán indudablemente,
Sin ninguna discusión,
De improviso o lentamente
Esqueleto pestilente
Calaveras del montón.

Y las gatas de figón,
Que se hacen llamar «Carmela»,
Por producir emoción
Y tienen el bodegón
Tan sucio que desconsuela;
Han de pagar su pereza
Que dá mortificación,
Sumiéndose de cabeza
En el fondo de la mesa,
A ser cráneos del montón

En fin, las Lupes y Pitas,
Las Eduwigis y Lolas,
Las perfumadas Anitas,
Las Julias y las Chuchitas,
Tan amantes de las galas;
Han de sentir por final,
Diciendo «Miren qué caso»,
El guadañazo fatal,
Y liadas como tamal,
Verán que llegó su ocaso.

Pero no quiero olvidar
A las lindas Margaritas,
Tan amantes de bailar,
Y a quienes gusta ostentar,
Porque se creen muy bonitas.
La muerte las ha de herir,
Sin mirar su presunción,
Y aunque se van a afligir
Yo les tengo que decir
«Calaveras del montón.»

Las Gumesindas e Irenes,
Las Gilbertas y Ramonas,
Que quieren siempre ir en trenes,
Y que alzan mucho las sienes
Porque se juzgan personas;
Las Melquiades y Rebecas,
Las Amalias y Juanitas,
Que unas son sucias y mecas
Y otras se juzgan muñecas
Y presumen de bonitas;

Las Romanas y Esperanzas,
Las Anastasias famosas,
Que son garbias y muy lanzas
Y parecen gatas mansas,
Porque son muy babiosas;
Todas, todas en montón,
Sin poderlo remediar,
En llegando la ocasión,
Calaveras del montón.
En la tumba han de parar. N.

Imp. de A. Vanegas Arroyo,
2ª de Sta. Teresa núm. 43.
México.—1913.

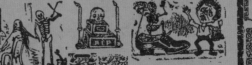

MERRY AND FESTIVE SKULLS
MEET THEIR END

Dusty chickpea sellers today,
deformed skulls tomorrow.

There are beautiful chickpea-vendors
wearing corsets and high heels.
Yet they too must end as skulls,
Skulls all in a heap.

Sometimes they're called "Rita,"
Others are known as "Consuelo"
And others are named "Pepita";
Death calls them all:
"Do not sleep, for I keep watch;
When the time comes,
And it is never far away,
Injured by a twist of rope,
Skulls all in a heap,
You will finish deep in the grave."
All end in the tomb.

All together in a heap,
Without remedy,
When the occasion comes
Skulls in a pile
All end in the tomb.

The Marcelas and the Sarahs
Enjoy trips to the cinema,
Even selling the spoons,
So as to daub their faces
Because they aim to please,
Without doubt
And without discussion,
Fast or slowly,
they will become pestilent skeletons,
skulls all in a heap.

The elegant Carolines,
Leave their homes to gossip
In shops and on street-corners,
Presenting a showy front,
Because they dress their hair in style,
Yet, with no farewells, they leave behind
Ribbons and crepe,
To plunge deep into the hole
Taking finery and blouses,
Heeled slippers and corsets.

Verses from *La Calavera Garbancera* (opposite),
illustrated by José Guadalupe Posada, 1913

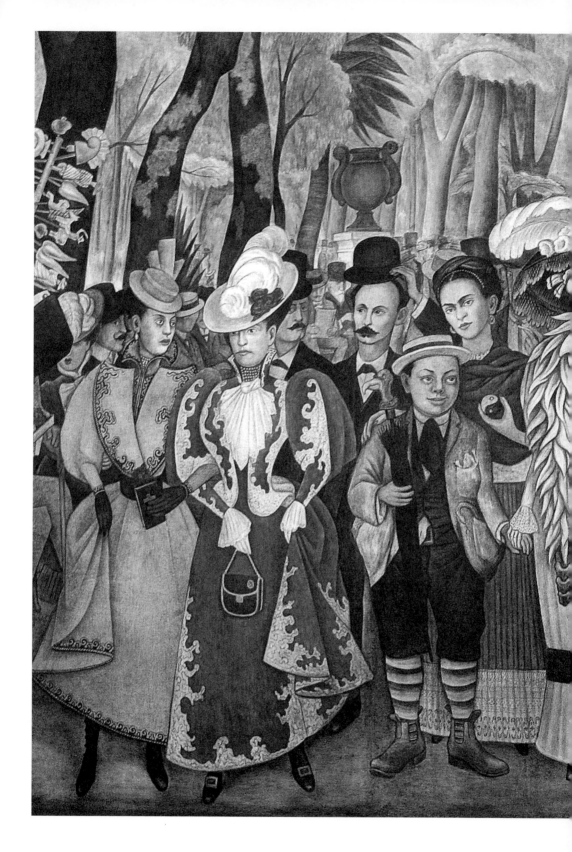

Diego Rivera, Part of the mural *Dream of a Sunday Afternoon in the Alameda Central*, 1947

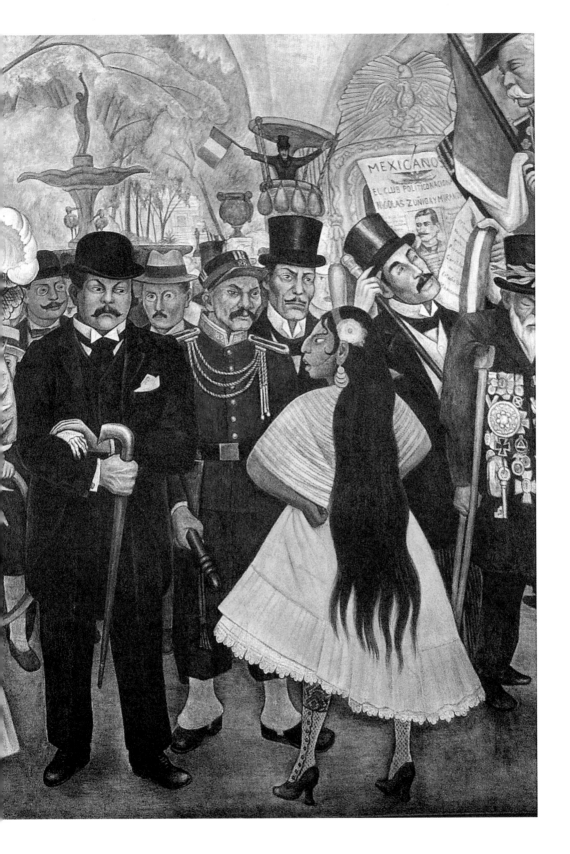

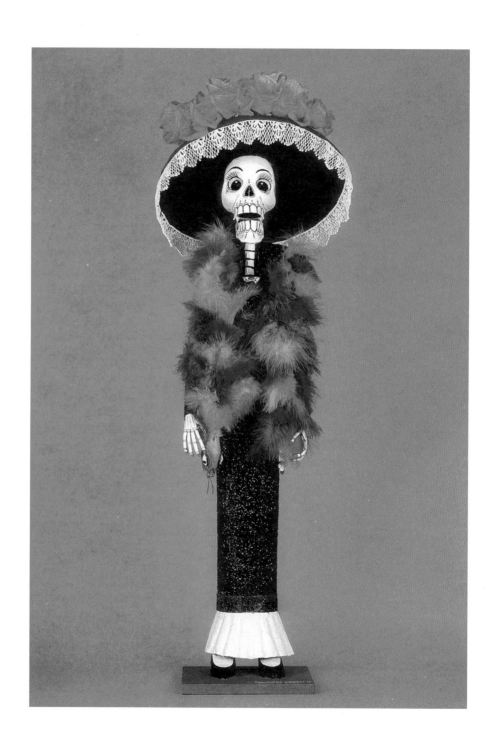

Above Leonardo Linares Vargas, Papier-mâché figure of La Catrina, Mexico City, 2002
Opposite Carlos Moíses Soteno Ambrosio, Painted pottery figure of
La Catrina from Metepec, State of Mexico, 2004

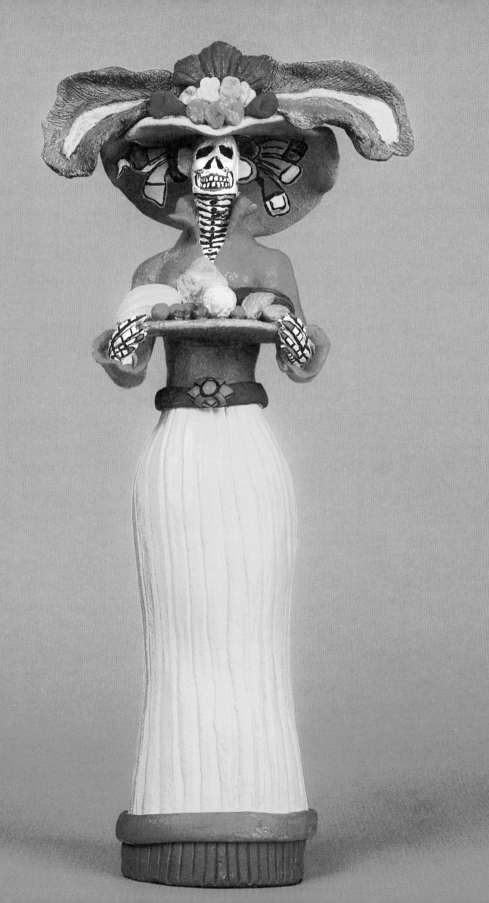

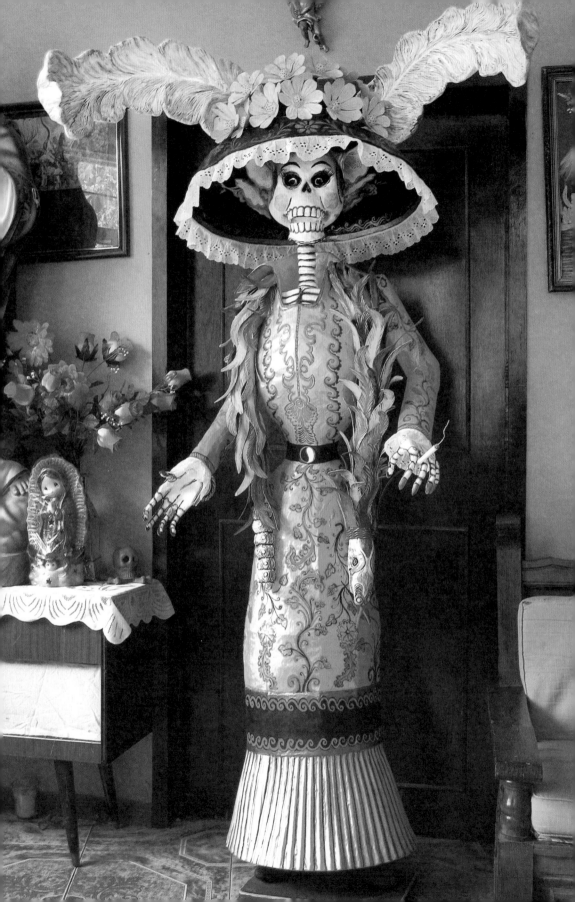

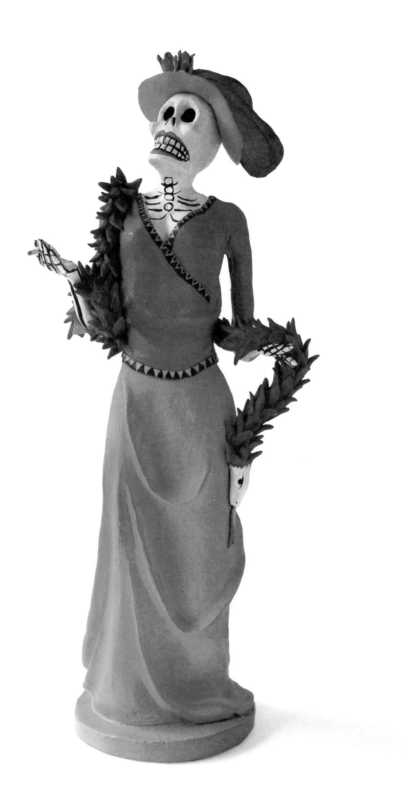

Opposite Felipe Linares Mendoza, Life-size papier-mâché figure of La Catrina, Mexico City, 2011
Above Israel Soteno Ambrosio, Painted pottery figure of La Catrina from Metepec, State of Mexico, 2007

4

URBAN MESSENGERS
OF MORTALITY

Death moves with the times in Mexico City and other conurbations.

Rural festivities for the returning souls are intimate celebrations shared by family and friends. In towns and cities, however, increasingly exuberant festivities are morphing into public spectacle.

Spectre, the 24th film in the James Bond canon, has been enormously influential. Released in 2015, it featured a carnivalesque parade of Posada-inspired characters with vast papier-mâché heads. Approximately 1,500 extras took part in this flamboyant spectacle. Wearing skeleton costumes, or elegantly made up to resemble dandified *Catrinas* and *Catrines*, they thronged the inner-city streets of the capital. The Mexico City Tourist Board, unwilling to be left behind, decided henceforth to make this a yearly event.

The first *Mega Procesión*, as the new "tradition" is called, took place on November 2, 2016—All Souls' Day is a national holiday in Mexico—and celebrants joined a choreographed parade of giant marionettes, acrobats, musicians, actors, dancers, and floats. By 2019, the estimated number of performers and spectators involved had reached a total of 2.6 million, putting the festival on track to rival the Rio Carnival. The influence of Hollywood has turned a family celebration into a theatrical extravaganza. In a similar spirit, Mexico City now stages *Mega Ofrendas* (massive altars) for the dead in the Zócalo (main square). Critics complain that "bigger" doesn't necessarily mean "better," but tourists and many city-dwellers have enthusiastically welcomed these recent additions to "popular" culture.

Unsurprisingly, urban populations have long had an appetite for jollity and visual fun. Visitors to the capital in the late eighteenth century described the sale of sugar figures and Day of the Dead memorabilia on November 1 and 2, and Diego Rivera's fresco *Día de Muertos* (1924; see page 107) showed Mexico City revelers enjoying sugar skulls and skeleton puppets. These items are still sold in most urban markets throughout Mexico.

In the run-up to the festival, the city of Toluca in the State of Mexico hosts *La Feria del Alfeñique* (Sugar Market), where sugar-workers offer fantastical and brilliantly colored creations on makeshift stalls under naked lightbulbs. In towns and cities, eye-catching images of bread figures are painted on the windows of *panaderías* (pastry stores) to advertise *pan de muerto* (bread for the dead) with simulated sugar-encrusted bones.

It is also usual for urban businesses to promote their wares with witty displays featuring skulls and skeletons made of wood or papier-mâché. Indeed, death is omnipresent in the city of Oaxaca—now a popular tourist destination during the Days of the Dead—as grimly festive tableaux proliferate in the entrances and courtyards of restaurants and boutique hotels. However, even such traditionally minded cities are not immune to the influence of Hollywood, which has led to the introduction of Zombie Walks and Halloween fashions. Witches' broomsticks, spiders' webs, devil costumes, masks for ghosts and ghouls, and plastic pumpkins are now an inescapable part of the cultural mix. On November 1 and 2, makeup artists in most city centers offer transformative opportunities to locals and tourists: for a small fee, faces are painted to resemble sugar skulls, spooky yet sexy. Tourists, national and foreign, dress in the clothing of Posada's characters to visit nightclubs and bars, or join night-time vigils in local cemeteries, where they accidentally trample on the tombs of the departed.

Keen to combat these alien trends, regional authorities in many places now promote local traditions by organizing *ofrenda* contests. In town halls and cultural centers, individuals or groups of people come together to construct scenarios featuring offerings for the dead. While some are highly imaginative, others strive for "authenticity." More extravagant by far are some of the installations staged by museums and art galleries. Until its demise in 1998, El Museo Nacional de Artes e Industrias Populares (The National Museum of Popular Arts and Industries) in Mexico City commissioned an ambitious annual installation from members of the Linares family (see Chapter 6), noted artists in the subject. One especially memorable installation was subsequently acquired by the British Museum in London. Cultural institutions linked with Frida Kahlo and Diego Rivera also continue to stage visually powerful *ofrendas* and installations for the Day of the Dead.

While the beliefs and practices that underlie Mexican celebrations for the souls of the departed deviate from the official teachings of the Roman Catholic Church, most priests have come to accept that celebrants are moved by religious faith and by a natural desire to remember their dead. The rise of evangelical Christianity, seen as a threat by the Catholic clergy, further motivates priests to accommodate the celebrations of their congregations. Far harder for the Church to accommodate, though, is the cult of *La Santa Muerte* (Holy Death). Support for this decidedly unorthodox supernatural figure is especially strong in the Tepito area of Mexico City. For her legion of devotees, who know her by a host of names, including *La Niña Blanca* (The White Girl) and *La Madrina* (The Godmother), this skeletal female figure is their protector. The personification of death, she offers her followers hope, healing, prosperity, and help with affairs of the heart. Although her critics associate her with violence, criminality, and narco-culture, the majority of her followers are from the urban working class. She is especially popular among homosexual, bisexual, and transgender communities excluded by the Catholic Church.

Once venerated clandestinely, *La Santa Muerte* now has shrines where her followers can pray openly and leave offerings. Images of this "folk saint," often shown with a globe and a scythe, are sold in esoteric stores together with prayer cards, candles of seven colors, and artifacts for home altars. Once a month, many devotees bring their own dressed image of *La Santa Muerte* to Tepito to be blessed by self-proclaimed officiants in rites that parallel those of the Catholic liturgy. Although the origins of *La Santa Muerte* are a subject for debate, she is currently thought to have over 10 million followers in Mexico, Central America, and parts of the United States. Her status rivals even that of Our Lady of Guadalupe, patron saint of Mexico.

The Mexican vision of Death—whether she appears on painted walls, printed T-shirts, market stalls, or roadside shrines—is deeply rooted in urban culture. Neither macabre nor sinister, Death presides over rituals and festivals both old and new. Indeed, in a bid to forge a national identity during the post-revolutionary era, intellectuals promoted regional traditions, including *El Día de Muertos*. In modern times, government institutions actively encourage involvement too. Shared celebrations draw on a perceived cultural ancestry. Transcending social barriers, they revitalize social solidarity and retain their relevance in the twenty-first century.

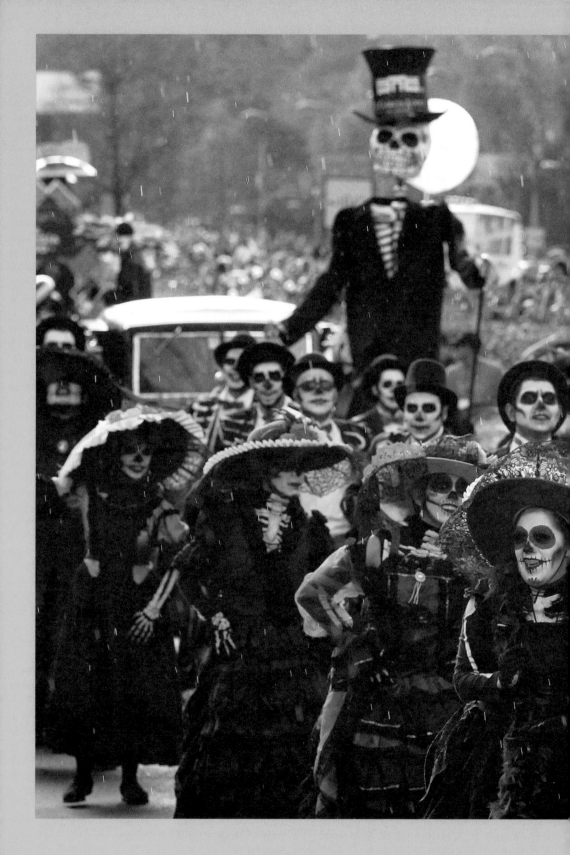

Day of the Dead parade in Mexico City, 2018

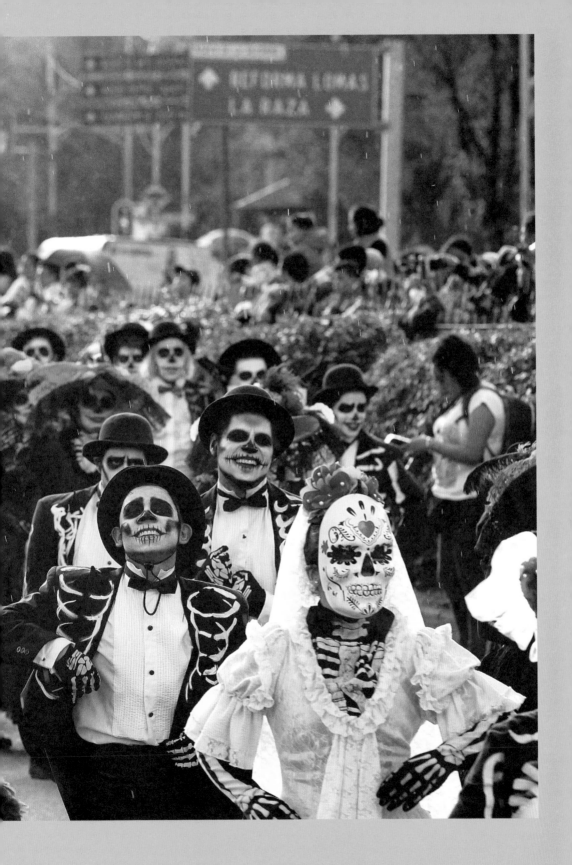

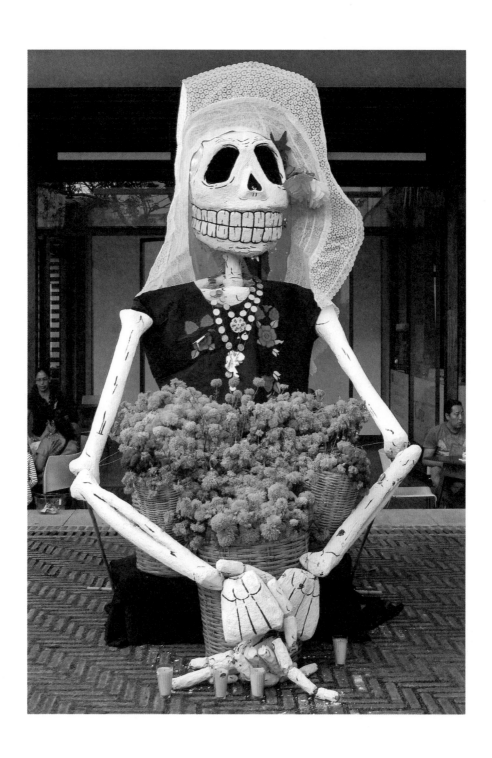

Above Skeleton figure wearing Tehuana dress, Oaxaca City, 2017
Opposite *Beyond Dreams*, painted wall in Santa María Reoloteca,
Tehuantepec, Oaxaca, 2012

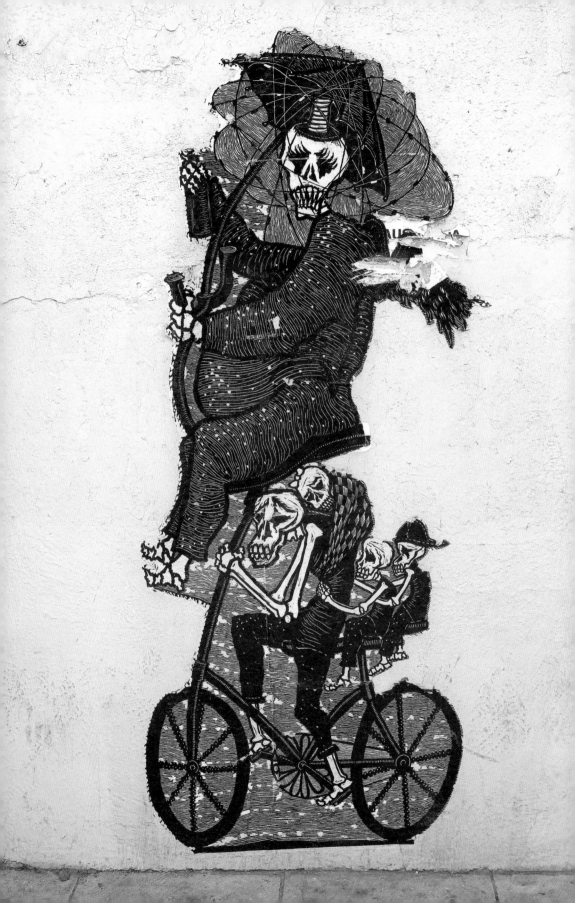

Opposite Printed paper image of La Catrina glued to a wall in Oaxaca City, 2017
Above Poster promoting a cultural event in Oaxaca City, 2010

Figures of *La Santa Muerte* on sale in Puebla City, 2010

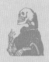

Es una verdad sincera
lo que nos dice esta frase
quo sólo el ser que no nace
no puede ser calavera.

It is the honest truth
as the saying goes
only he who is never born
will not become a skeleton.

Day of the Dead verse (anonymous)

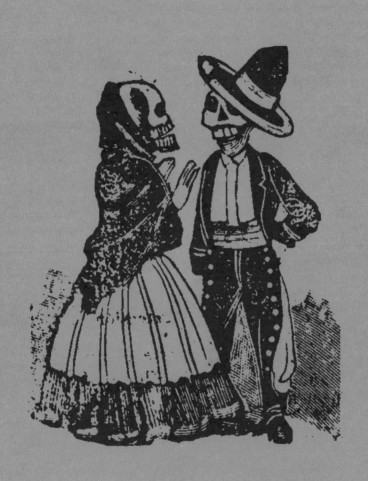

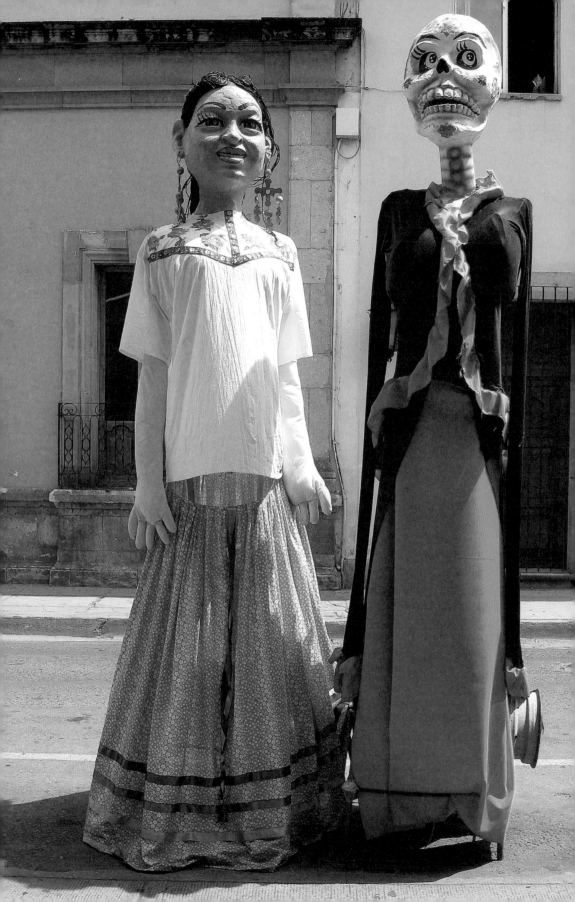

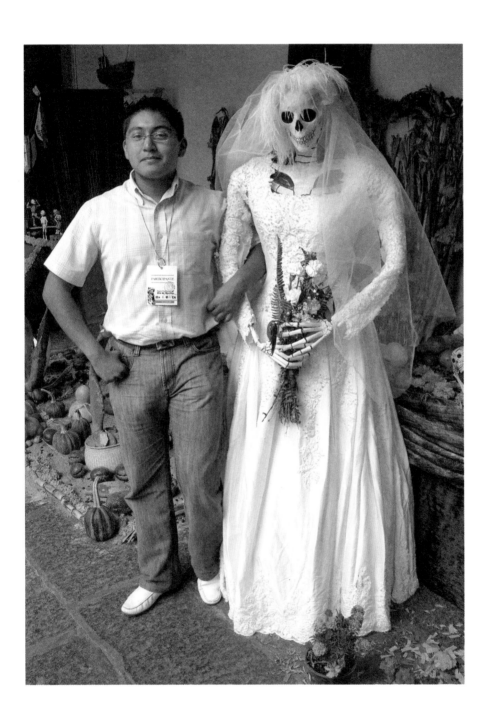

Opposite Festival figures with papier-mâché heads, Oaxaca City, 2009
Above Young man posing for the camera with his skeleton bride, Puebla City, 2011

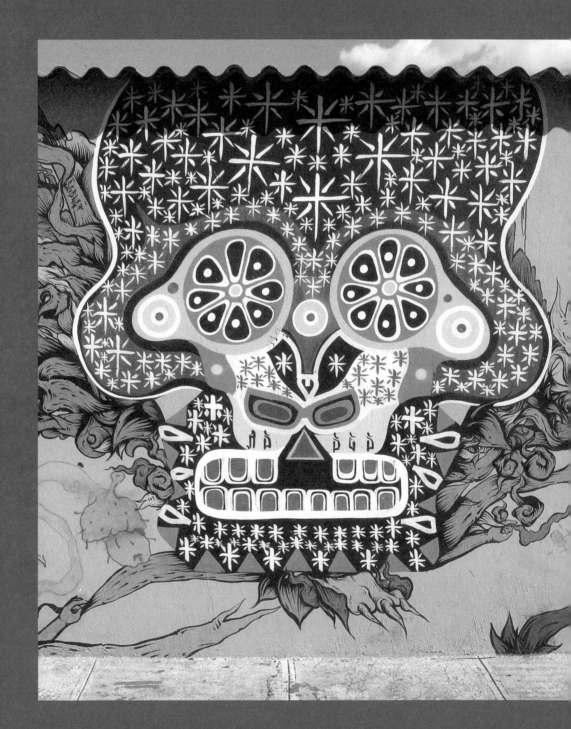

Opposite Wall with enormous painted skull, Puebla, 2011
Top Baker's window advertising "best bread for the Day of the Dead," Mexico City, 2011
Above Sugar skulls sold in Toluca, State of Mexico, 2011

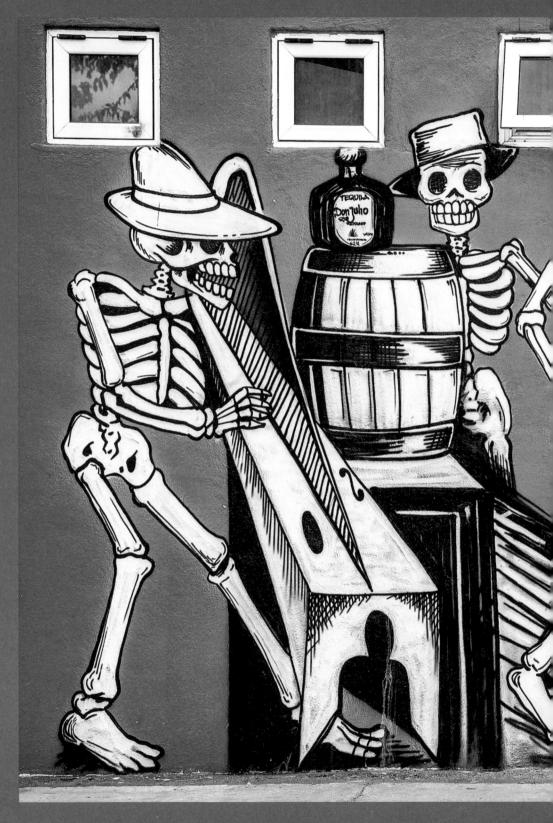

Mural inspired by Posada's famous *calavera*
(see page 36), San José del Cabo, Baja California Sur

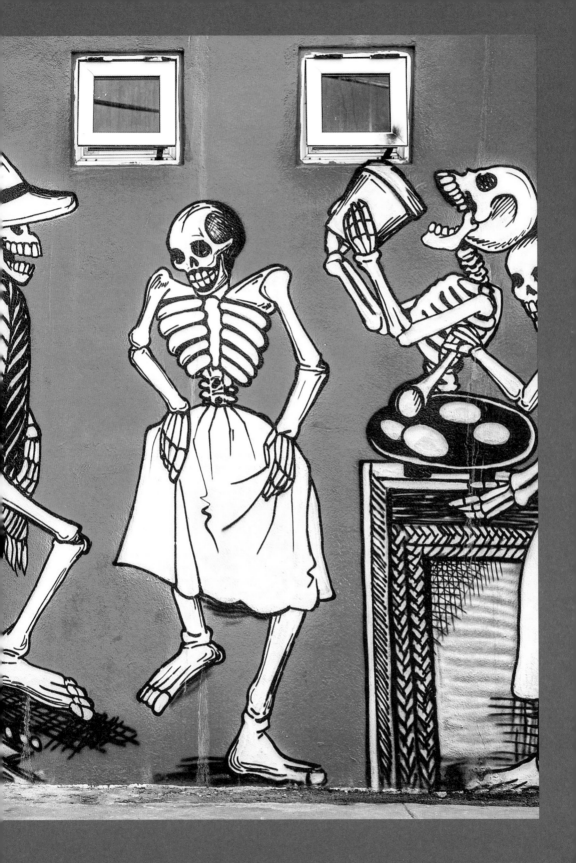

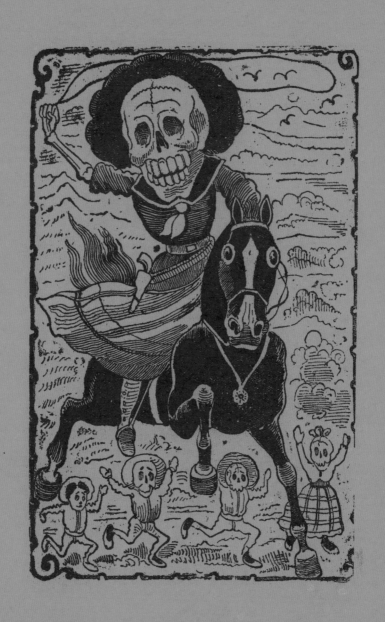

5

DEATH AND POPULAR ART

Craft skills are at the forefront of Mexican popular culture.

This is especially true during the Days of the Dead, and makers start production weeks or even months in advance. As mid-October approaches, markets fill with incense-burners, vases and candleholders, grimly humorous toys, embroidered cloths, and cooking vessels. These items, generally unsigned, are often sold far from their place of origin. Yet it is the output of anonymous creators that gives the festival its unique character and visual power. Combining raw materials, techniques, and forms inherited from the cultures of ancient Mexico and Europe, folk artists find tangible ways to express the deeply held beliefs that underlie celebrations for the departed.

The ephemeral nature of much Mexican folk art is exemplified by the skill and dedication of sugar-workers. Their intricate creations, sold on makeshift stalls in Toluca, Puebla, Oaxaca, and other urban centers, include colorfully decorated sugar skulls, their eye sockets embellished with metallic foil, and figures in the shape of stags, hearts, angels, and souls in purgatory. Styles and recipes vary from region to region; for example, makers in Malinaltenango and Sultepec in the State of Mexico fashion doves, lambs, and hands holding sprays of roses from *dulce de pepita (*sweetened pumpkin-seed paste). Offerings of this type are often placed on home altars to welcome the *angelitos* (little angels), as the souls of dead children are known.

Ephemeral cut-out paper banners with the delicacy of lace are also displayed on home altars. Using a selection of sharp chisels, makers hammer through layers of tissue paper or metallic foil, giving form to skeleton dancers, flowers, and angels.

Toymakers and miniaturists in several states fashion humorous playthings that move in ingenious ways. Although these seasonal toys are occasionally offered to the *angelitos*, they are usually intended for the living. Early photographs and written accounts show that the custom is not new.

Today, as in the past, markets in Oaxaca, Puebla, and Mexico City sell tiny coffins and cardboard skeletons that dance at the pull of a string. Skeletons of painted pottery caricature the activities of everyday life. These include couples getting married, priests hearing confession, people playing football, and skeletons kneeling in prayer at the graveside of dead relatives. In medieval Europe, paintings and carvings showed the "dance of death," in which the living from all social classes frolic with skeletons as a reminder of their mortality. In modern Mexico, death is similarly regarded as an equalizer, striking down rich and poor, powerful and weak.

In recent years, growing numbers of makers have started to sign their work. The town of Metepec in the State of Mexico is home to several well-known ceramic artists, who reject anonymity and sell to collectors. The cycle of life and death is a popular theme throughout the year. Members of the Soteno family specialize in making "trees of life," an idea originated in the 1940s by Modesta Fernández Mata, who started to model small representations of Adam and Eve in the Garden of Eden. Today, trees of life are sculptural works that often reach vast proportions, which is possible because clay from nearby pits is mixed with bulrush down for malleability and strength. Frida Kahlo and Diego Rivera were keen collectors of work from Metepec, and inspired makers to use the brilliant colors that characterize production today.

Ceramic artists in Metepec often say that their skill is inherited from the Matlatzinca, who dominated the region before the Spanish Conquest. By contrast, Carlomagno Pedro Martínez (b.1965) attributes his creativity to his Zapotec ancestry. *Barro negro* (black pottery), distinguished by its brilliant sheen, has been made since pre-Hispanic times in the Zapotec town of San Bartolo Coyotepec in Oaxaca state. Finished clay pieces, their surfaces carefully polished, are fired in an underground pit, the opening of which is sealed with broken shards and mud to reduce the oxygen inside. This allows the pottery to absorb soot and smoke from the wood fire and emerge deep black. Carlomagno's finely hand-modeled work explores the cultural identity of his region. Skeletons, devils, and supernatural beings from Zapotec mythology are often represented. "Death is ever-present in our culture," he says. "It's how we express our love for life. As Carlos Pellicer, the Tabascan poet, used to say: 'Mexicans have two obsessions—their love of flowers and their fondness for death.'"

Unlike pottery, papier-mâché is a post-Conquest skill, and few handle it better than the Linares family (see Chapter 6). However, other makers also rely on papier-mâché to earn a living. Skull masks and skeleton figures from the states of Mexico and Guanajuato find their way to seasonal markets across the country despite the encroachment of plastic toys. Saulo Moreno (1933–2018), a celebrated papier-mâché artist, developed his own unique style over several decades. Using wire armatures and car paints, he turned bakers, newspaper sellers, wrestlers, musicians, and prostitutes into skeletons. As a boy he lived in Mexico City with his grandmother, who worked as a market trader, and Saulo's visual sense of the world was shaped by the seasonal crafts he saw around him: "As a small child I played with toy skulls and skeletons. In Mexico, that's how we learn about mortality."

For Saulo Moreno, as for many other folk artists, life and death go hand in hand: "Although *la muerte* is represented with irony and humor, she inspires total respect. I share my daily life with her. I show her in different guises, but I never mock her. We are all going to die. As the saying goes: 'You are dust, and to dust you will return.' Perhaps we are preparing ourselves psychologically for that final step. Here in Mexico, we never hide from death. And we never tire of representing her."

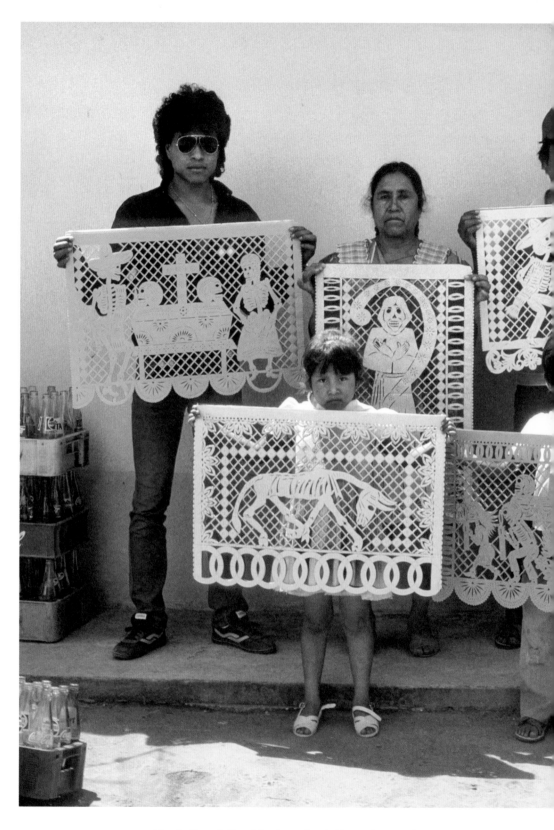

Maurilio Rojas (left) and family members holding up banners of cut
tissue paper made for the Day of the Dead, San Salvador Huixcolotla, Puebla, 1989

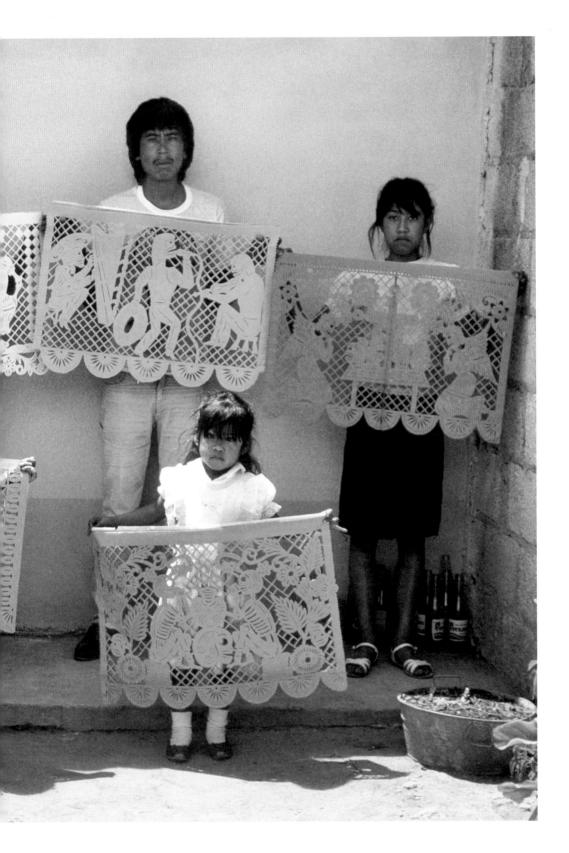

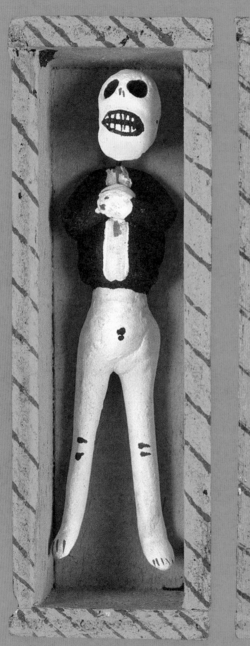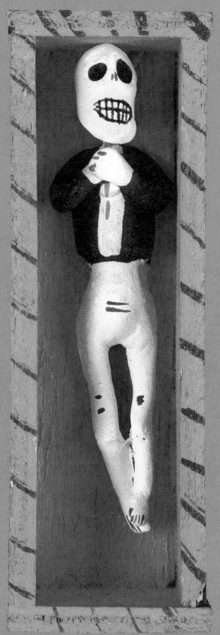

Acostúmbrate a morir
antes que la muerte llegue,
porque muerto soló vive
el que estando vivo, muere.

Prepare to die
before death comes,
for only he who living dies
can dying, live.

Verse on an altarpiece in the Colonial former convent
of Tepotzotlán, State of Mexico

Opposite Miniature skeletons of painted pottery
in wooden coffins, Puebla City, 1989

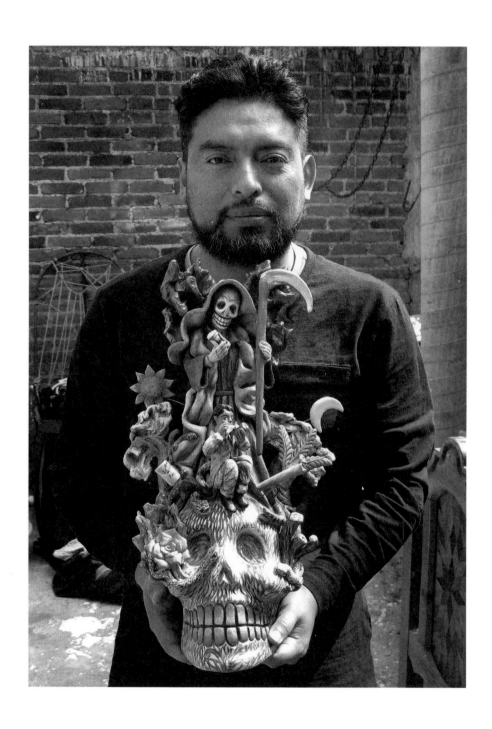

Above Carlos Moíses Soteno Ambrosio with hand-modeled ceramic artwork
for the Day of the Dead, Metepec, State of Mexico, 2019
Opposite Carlos Moíses Soteno Ambrosio, Painted pottery "tree of life"
with ancient gods, Metepec, State of Mexico, 2012

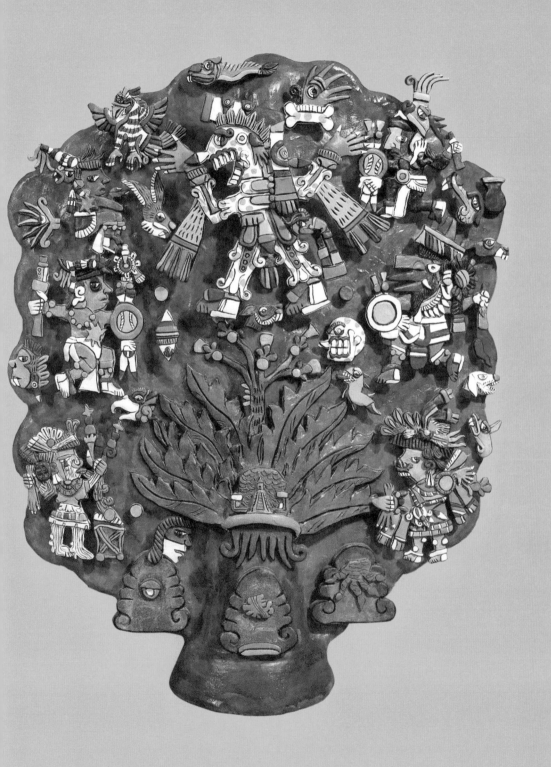

Miniature skeletons of painted pottery in glitter-lined, glass-fronted wooden boxes, Puebla City, 2011

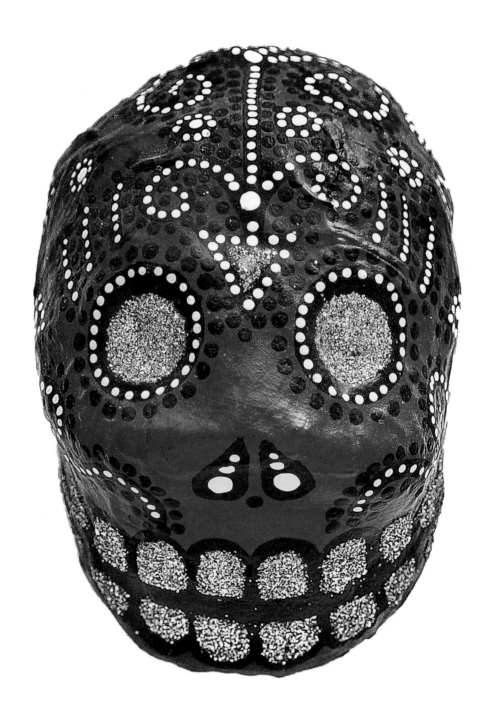

Above Painted papier-mâché skull with glitter, Mexico City, 2016
Opposite Painted pottery skulls displayed in Coyoacán market, Mexico City, 2019

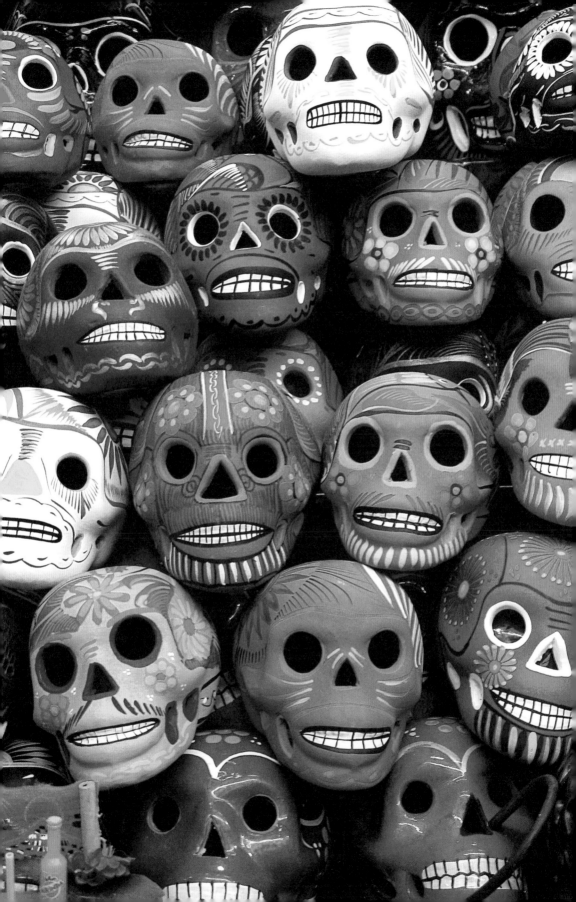

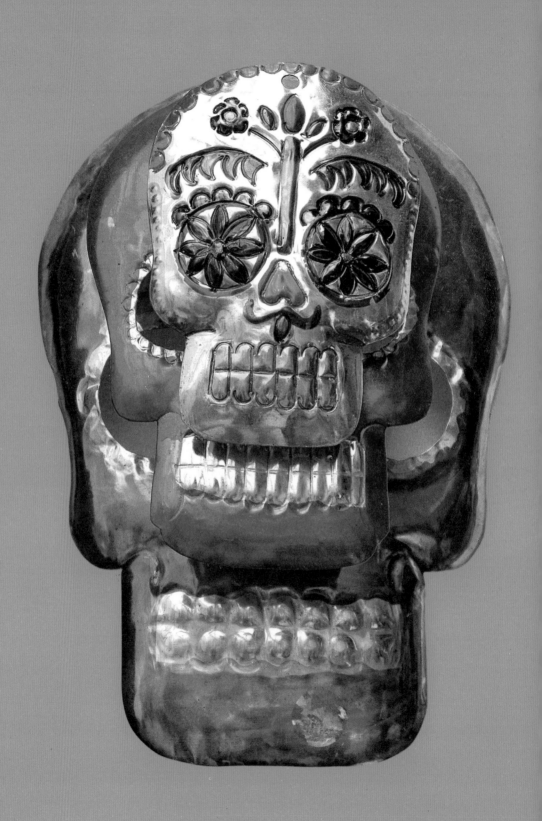

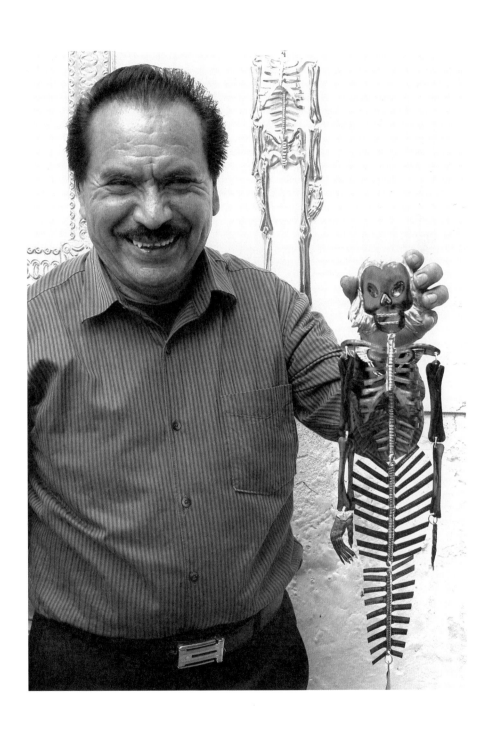

Opposite Arturo Sosa Mendoza, Superimposed tin skulls, Oaxaca City, 2012
Above Tinsmith Arturo Sosa Mendoza with a skeleton mermaid, Oaxaca City, 2010

Que bonito es el mundo;
Lástima es que yo me muero.

**How beautiful is the world;
It is a pity that I must die.**

Chorus of voices heard by John Lloyd Stephens
(*Incidents of Travel in Yucatan*, 1843)

Opposite Arturo Sosa Mendoza, Skeleton dancers
of unpainted tin, Oaxaca City, 2011

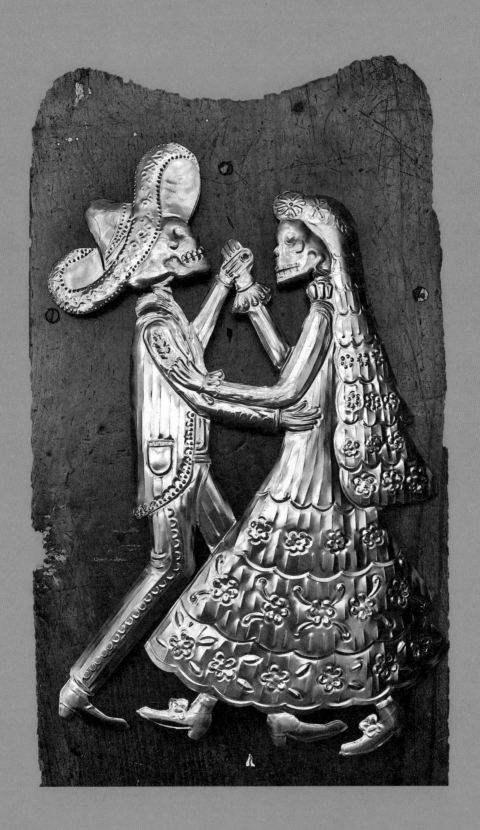

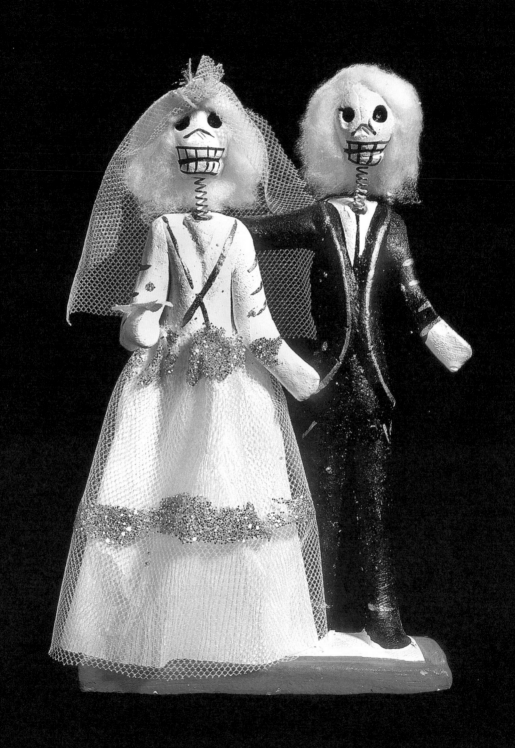

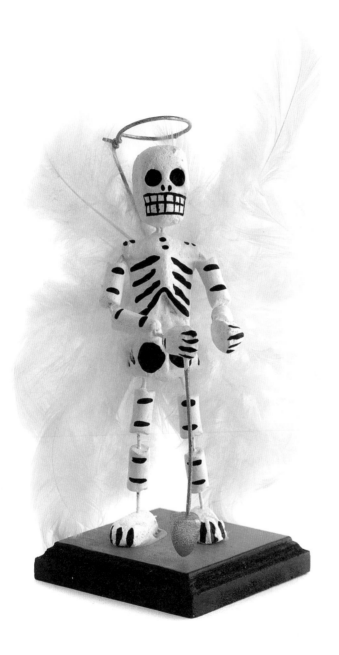

Opposite Miniature wedding couple of painted pottery with coiled spring necks, Oaxaca, 2002
Above Miniature angel of death of painted pottery and wire with feather wings, Puebla City, 2011

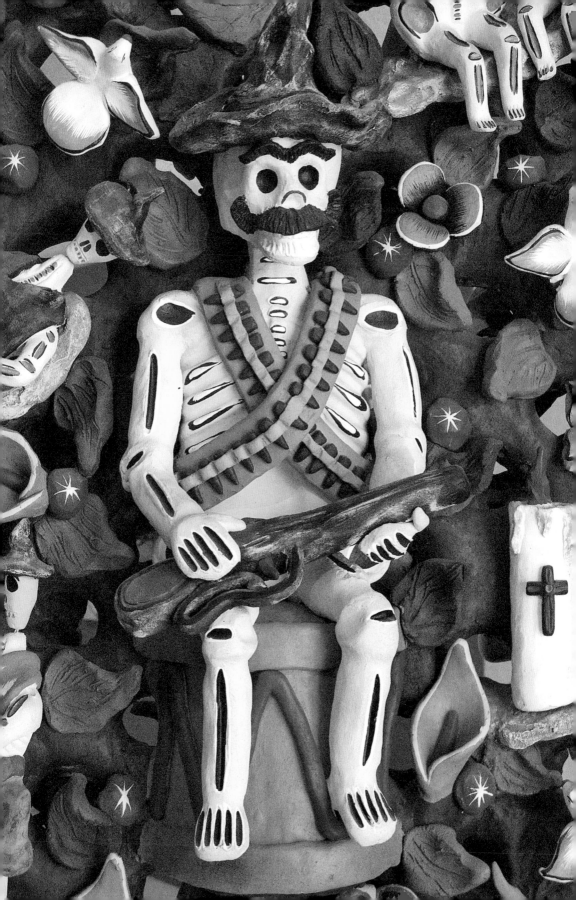

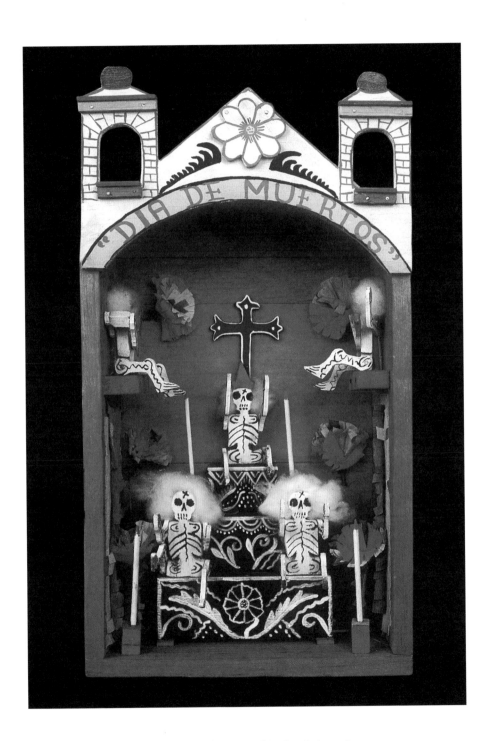

Opposite Juan Carlos Nonato Díaz, Revolutionary from
a painted pottery "tree of life," Metepec, State of Mexico, 2016
Above Painted wooden scene with paper flowers and skeletons with movable limbs, c.1977
Overleaf Sugar skulls with metallic foil, Toluca, State of Mexico, 2011

SAULO MORENO

Saulo Moreno (1933–2018) moved to
Michoacán as an adult, but spent his
childhood years with his grandmother in
Mexico City. She sold vegetables in a vast
covered market. He enjoyed the smells,
the cries of the traders, and the visual
excitement: "The market was my first school,
my first academy; it gave me my introduction
to popular art. There were handmade toys,
puppets in clusters, devils and skeletons
that moved at the pull of a thread... When
October came, there were flowers, candles,
and sugar skulls for the Day of the Dead."
As a teenager, Moreno worked in his father's
carpentry shop, studied art in the evenings,
and became a professional sign-painter.
Then, in his twenties, he found his vocation:
"I began making skulls and skeletons from
bits of wood, wire, and paint, eventually
moving on to wire and paper."

Moreno's work has been shown
and collected by major institutions.
Importantly, it is greatly admired by his
fellow artists. "No creative person is ever
satisfied, and I am still learning," Moreno
would say. "My style has changed over time,
but my themes and my inspiration remain
essentially the same. Death is a very visual
subject. I have always looked on Posada as
my mentor, yet I have my own vision of the
world. When we die, our bodies decompose
and feed the earth. We are all part of the
cycle of death and regeneration."

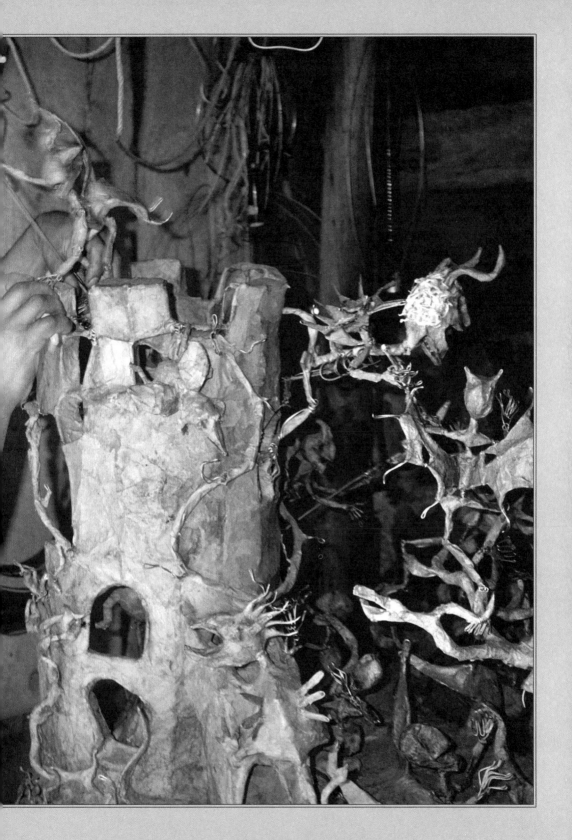

Saulo Moreno making a sculpture of wire and
papier-mâché in Tlalpujahua, Michoacán, 1995

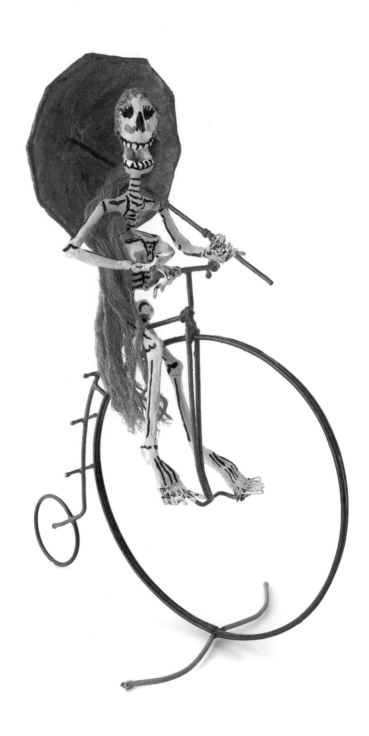

Saulo Moreno, Painted papier-mâché and wire figures from Tlalpujahua, Michoacán
Above *La Muerte* riding a penny-farthing bicycle, c.2009
Opposite Skeleton wrestler, 1990s

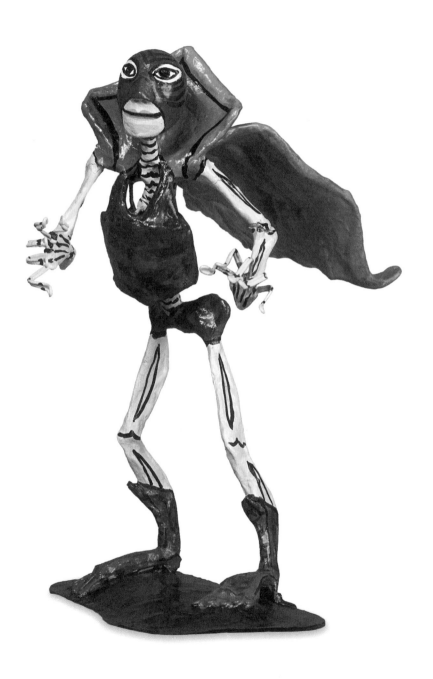

POPULAR SAYINGS

De aquí a cien años,
todos seremos pelones
In a hundred years,
we'll all be bald

Los muertos al cajón
y los vivos al fiestón
The dead go to their coffins,
the living go to the party

Entre flores nos reciben
y entre ellas nos despiden
They greet us with flowers
and bid us farewell with flowers

Solo el cobarde
muere dos veces
Only a coward dies twice

Al muerto y al consorte,
a los tres días no hay
quien los soporte
A cadaver is like a spouse,
unbearable after three days

Vale más un cobarde
en casa, que un valiente
en el cementerio
It's better to be a coward
at home than a hero in
the cemetery

Al vivo todo le falta
y al muerto todo le sobra
The living have too little
of everything, the dead have
too much of everything

Muerto el perro,
se acabó la rabia
When the dog dies,
the rabies is gone

Nadie sale vivo de esta vida
Nobody leaves this life alive

Matrimonio y mortaja,
del cielo bajan
Marriage and shroud,
both are sent from above

De gordos y glotones
están llenos los panteones
Graveyards are filled by
fat people and gluttons

El matrimonio es la vida
o la muerte, no hay
término medio
Marriage is life or death,
there's no middle way

Buen amor y buena muerte,
no hay mejor suerte
To be lucky in love and death,
there's no greater good fortune

Si me han de matar
mañana, que me maten
de una vez
If they're coming to kill me
tomorrow, let them kill me today

Poco veneno no mata
A small dose of
poison doesn't kill

Lo que mata no
es la muerte,
sino la mala suerte
Bad luck is the killer,
not death

En muerte y en boda,
verás quién te honra
In death and in marriage,
you will see who honors you

El asno sólo
en la muerte
halla descanso
The donkey finds rest
only in death

Cuando venga la parca,
no lloren por mí
When death comes,
don't weep for me

Todo hombre muere,
no todo hombre vive
All men die,
but not all men live

Al fin que para morir nacimos
In the end we were born
to die

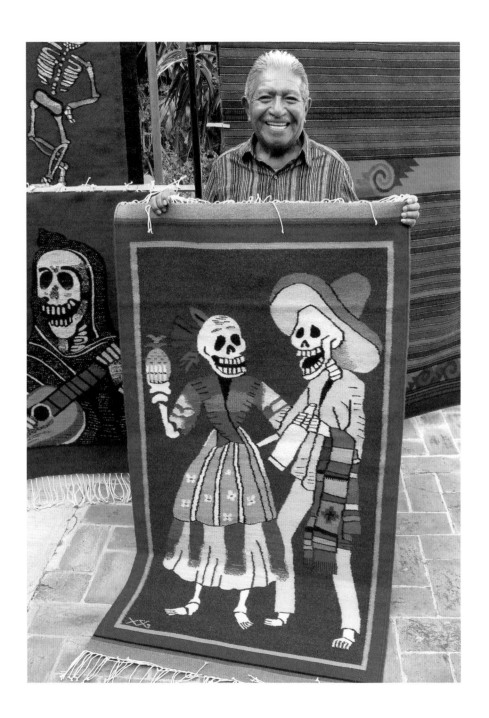

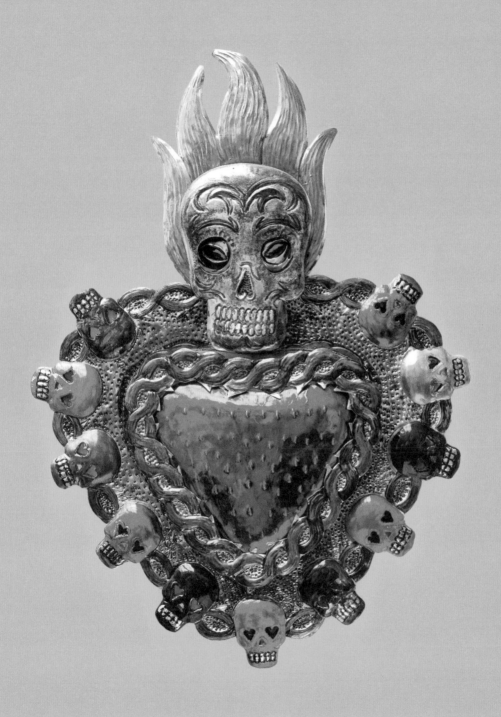

Opposite Isaac Vásquez García with one of his tapestry-woven wool rugs
in the Zapotec town of Teotitlán del Valle, Oaxaca, 2017
Above Arturo Sosa Mendoza, Painted tin heart surrounded by skulls, Oaxaca City, 2012

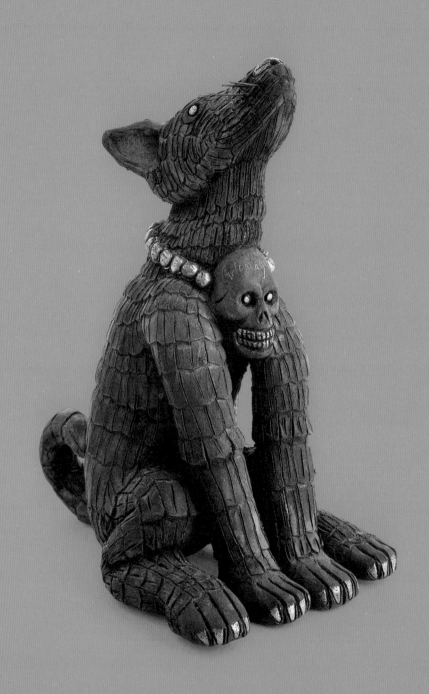

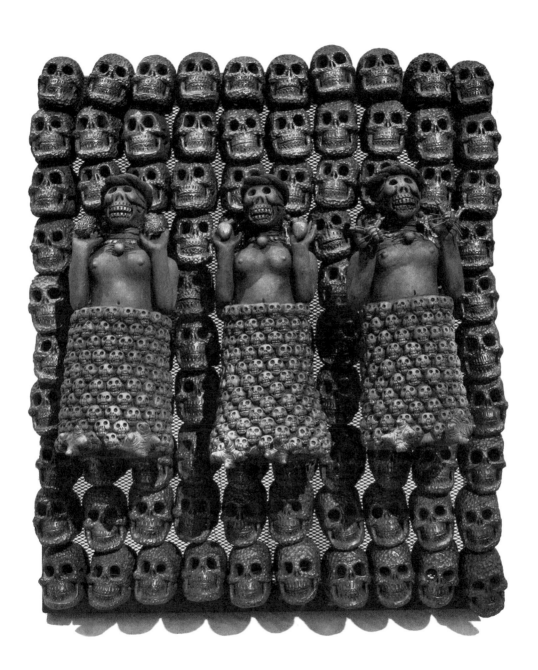

Carlomagno Pedro Martínez, Hand-modeled ceramic sculptures, San Bartolo Coyotepec, Oaxaca
Opposite *Nahual* or *tonal* (supernatural companion animal), 2009
Above Zapotec death goddesses, 2011

6

THE LINARES FAMILY:
CHRONICLERS IN PAPIER-MÂCHÉ

Four generations of the Linares family, highly inventive and technically brilliant, have transformed the craft of papier-mâché in Mexico.

In the skilled hands of these celebrated *cartoneros* (workers in papier-mâché), it has become an internationally acclaimed art form, collected and displayed by museums and galleries in many countries. The transition started with Pedro Linares Jiménez (1906–1992). A *cartonero* like his father, Don Pedro sold seasonal toys and festive ephemera in Mexico City. For Holy Week, he made masks, Roman helmets, and enormous wire and papier-mâché skeletons and horned devils known as Judas figures. For Christmas, he made *piñatas* (decorated animals or stars containing candy) and figures for Nativity scenes. Importantly, though, he also invented fantastical and brightly painted creatures, which he named *alebrijes*. "These figures are ugly, very horrible. But at the same time they are very beautiful," Don Pedro would say of his visionary creations. His three sons—Enrique, Felipe, and Miguel Linares Mendoza (b.1933, 1936, and 1946 respectively)—helped their father as young children. Today, Felipe and Miguel carry on the family tradition, as do their sons and even grandsons.

Papier-mâché, which originated in China and spread across the world, was introduced into Mexico during the colonial period. Like most *cartoneros*, the Linares use torn-up kraft paper for their constructions, glueing each layer to the one below with *engrudo* (wheat-flour paste). Having worked as a mason, Don Pedro was also able to adapt various building techniques for making his models. Plaster-of-Paris molds are used for repeat elements, such as heads and bodies. Assembled in sections, figures are individualized later as details are added. Colored paints are applied with homemade cat-hair brushes over a coat of white. The work of the Linares family, no longer regarded as ephemeral, is signed by each maker to show individual authorship.

Death, the great equalizer, is an important theme throughout the year for these imaginative and witty *cartoneros*. They have become chroniclers for the modern age. "Mexican Death," as the poet Octavio Paz noted in *The Labyrinth of Solitude*, "is the mirror of Mexican Life." The satirical engravings of José Guadalupe Posada are an important source of inspiration. From the workshops of the Linares family come skeleton disco-dancers, fire-eaters, punk rockers, musicians, and tourists clad in baggy Bermuda shorts holding hamburgers and bottles of Coca-Cola. Death holds no terror for Felipe Linares: "Skulls and skeletons are part of Mexican culture. We all know that we must die, that we will become bones in the end. We regard death with humor, but also with affection and respect. For us, death is part of life." This belief is expressed in a series of works that Felipe calls *La Muerte Enramada* (Death Sprouting Leaves). Luxuriant foliage, birds, and butterflies seem to erupt from the bony frame of a skeleton. Skulls, in the series *La Calavera Primavera* (The Springtime Skull), carry the same message. Plants and birds emerge, and eye sockets are painted with brilliant flowers.

Felipe and his brother Miguel still live behind the Sonora market, near the vast and sprawling food market of La Merced. Theirs are urban ties and urban loyalties. "We are used to the bustle of people and traders," Felipe explains. Commitment to their community has found expression in several large-scale works. In response to the Mexico City earthquake of 1985, the Linares family created a vast tableau for the National Museum of Popular Arts and Industries. It showed nearly 50 skeleton figures caught up in the drama of devastation and rescue. An earlier tableau from 1984, called *El Apocalipsis Atómico o Morirá la Muerte* (The Atomic Apocalypse or Will Death Die?), featured the Four Horsemen of the Apocalypse suspended above a vast cityscape. On the ground, skeleton figures burned car tires, ate junk food, and scavenged from a trash heap. According to Felipe, they represent the ills of modern urban life. This vast installation, now owned by the British Museum, was shown in London to much acclaim in 1991–3 during the exhibition *The Skeleton at the Feast: The Day of the Dead in Mexico*.

The Linares family's other achievements are legion. Their work has been included in exhibitions in Chicago, Edinburgh, Glasgow, Los Angeles, Mexico City, New York, Paris, and Toronto, and the film *Under the Volcano* (1984), directed by John Huston, featured a specially commissioned series of their papier-mâché skeletons. Although the makers were not credited, their

figures were shown behind the opening credits. Unsurprisingly, the work of the Linares family has become a symbol of national identity. Copied by other *cartoneros*, their exquisitely painted *alebrijes* and their humorous skeleton figures continue to outdo the efforts of less talented imitators.

Now in his eighties, Felipe is busy every day in his rooftop workspace. While newly glued sections dry and harden in the open air, finished figures await collection in the rooms below. His sons Leonardo, David, and Felipe Jr. (b.1963, 1967, and 1976 respectively) are proud of their modest and unassuming father, and of their artistic heritage. Leonardo explains, "People visit us from everywhere. Often they ask if we find it depressing to be so closely involved with death. I explain that we never find our work sad. But then we don't regard the Day of the Dead as sad. On the contrary, we feel joyful when this day arrives each year because we remember the departed and pay them homage." Like his father, he has enormous respect for Posada: "He illustrated his *calaveras* a long time ago, yet they always seem current and up to date. Our three-dimensional skeletons owe a lot to Posada's engravings. Think of La Catrina—she never goes out of style. Of course we don't just draw on the past. We also enjoy making modern-day skeleton figures. When Michael Jackson died, for example, a collector in the USA telephoned immediately, asking me to make him as a *calavera*." Leonardo is philosophical about his own demise: "There is no escaping *la muerte*. You can be married, you can be single. But Death will have you in the end. Death will be my last love."

Felipe Linares Mendoza, 2011

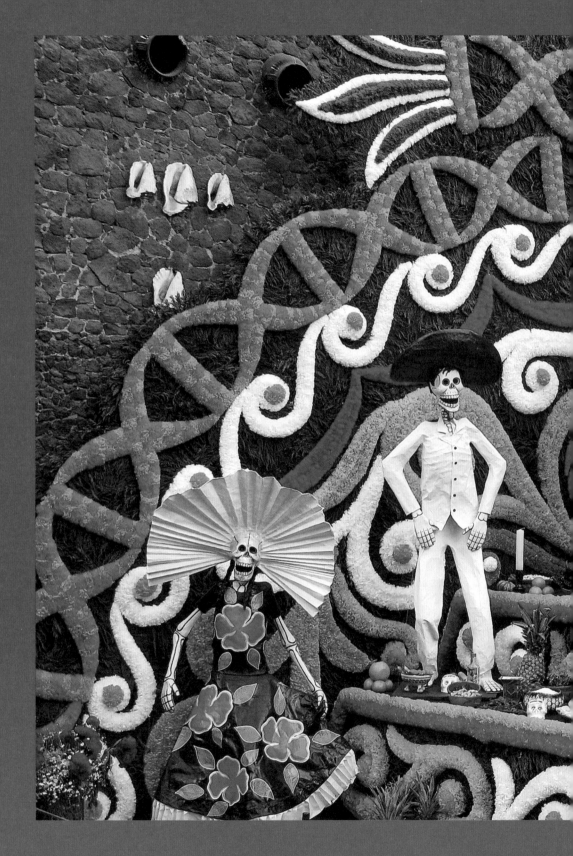
Day of the Dead installation with skeleton figures by the Linares family at the Museo Frida Kahlo, Mexico City, 2017

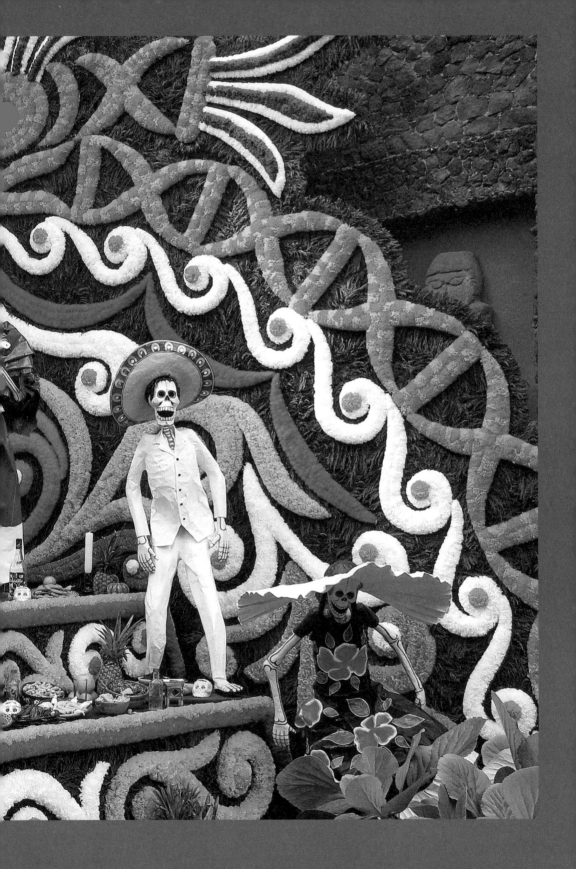

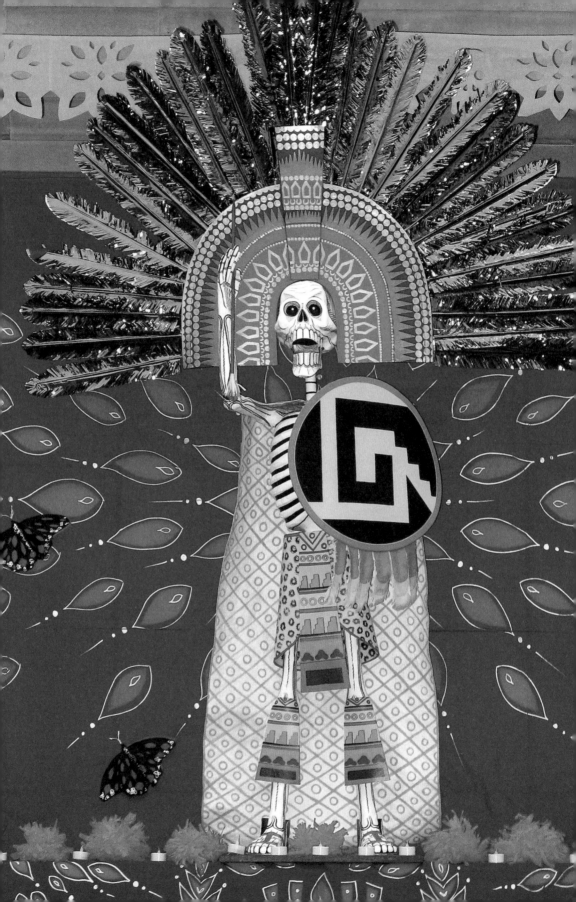

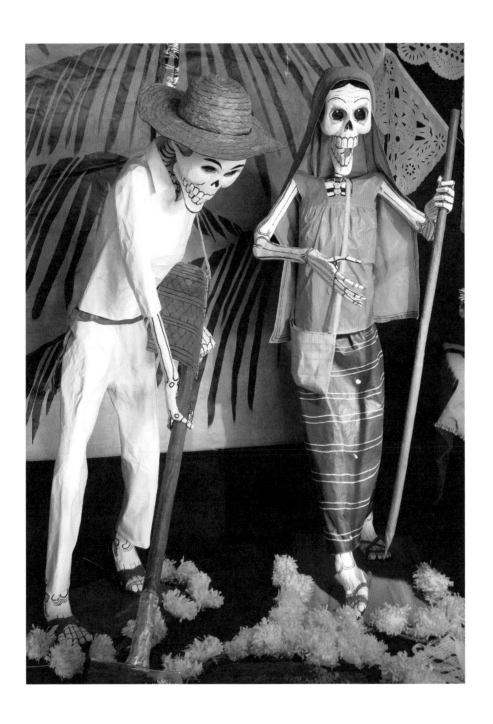

Opposite Leonardo Linares Vargas, Skeleton figure of the Aztec ruler
Moctezuma displayed at the British Museum, 2009
Above Felipe Linares Mendoza and Leonardo Linares Vargas,
Life-size skeleton peasant couple shown in Toronto, 2012

LA CALAVERA DE CUPIDO.

También Cupido el travieso
Después de muerto es tronera,

Y llora de amor el hueso
Como todo calavera.

Fué sacerdote travieso,
Gustaba del bacalado,
Y le metía al colorado
Cuando le lloraba al hueso;
Comió también mucho queso
A solas con sus gatitas,
Tuvo sobrinas bonitas
Y aun hijas de confesión,
Fué un padrecito glotón
De muy sabrosas carnitas.

Era una preciosa güera
Que en este mundo hizo raya,
Gustó de ponerse falla,
Capota y hasta montera;
Y sobre su calavera
Hoy luce su añeja moda,
Al andar menéase toda
Como un bergantín velero,
Y, ¡ay! vales, con ese cuero
Ni el frío, creo, nos incomoda.

También esta fué en vestir
Viciosa y usaba cola,
Llevaba sombrilla y gola
Cuando iba la misa á oir;
Le gustaba perseguir
Solteros para casarse,
Mas quiso tanto adornarse
Con chinos, que su tontera
La hizo ser fea calavera
Y á nadie puede quejarse.

Gerdarme de profesión
Murió con recuerdos malos,
Resultado de los palos
Que dió con su ocupación;
Se fué con resignación
En busca de unos trompetos,
Y aquellos malos sujetos
Me lo apalearon un día
Y fué á la difuntería
A cuidar los esqueletos.

Ámeme por compasión,
Pedazo de la otra vida!
—¡No me hable ya de pasión,]
Calavera corrompida!

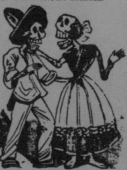

—¿Habrá perdido la fe?
—No; mi corazón espera.
—Caramba, piénselo usté.
—Pues venga, mi calavera.

—Reniego del matrimonio,
—Pues ya, maldito, qué espera
Y zás en la calavera
Dió golpes á Ñor Antonio.

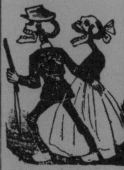

Y de un sepulcro brincó
El Germán, y fué de veras,
Y con la vieja cargó
Corriendo entre calaveras.

Quien de sorbete y bastón
Camina por las aceras
Tiene en la bolsa de veras
Por lo menos un tostón;
Y es llegada la ocasión
De caminar sin tontera,
Y pedir á algún tronera
Para la copa y el sandwisch,
Que todos dan en el tianguis
De muertos, la calavera.

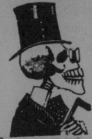

De ... no tiene una queja
Y pedir es importuno,
Muerte desmolada y vieja,
Calandria sin desayuno,
Tiznada olla sin oreja;
Que con sus frases sencillas
É importunas preguntillas
Me pide su calavera,
Espere la muy tronera
Un muerto con sus canillas.

—¡Oiga! vale no la arrisque
Ni beba como animal,
Y póngame un decimal
Si no quiere que lo cisque,
No me haga usté misque-misque
Con toda la trompa entera,
Pues aunque la gorda quera,
Desde luego me va á dar
Un decimal para echar
Un trago de calavera.

—Pos manaría usté salió
Dende el fondo del panteón
A buscarse su jaión
Pero aquí sí la jerró;
Con muertos no verso yo,
Ni le he de dar lo que quera;
Pues es la rata primera
Que al salir yo de mi choza,
Me pide la muy chismosa
Un fierro por calavera.

México —Imprenta de Antonio Vanegas Arroyo, Calle de Santa Teresa número 1.

Calaverita de dulce,
mi panecito de muerto
detener quisiera el tempo
tan incierto, tan incierto.

**Little candy skull,
My little bread of the dead
I wish I could stop time
so uncertain, so uncertain.**

Traditional verse for children

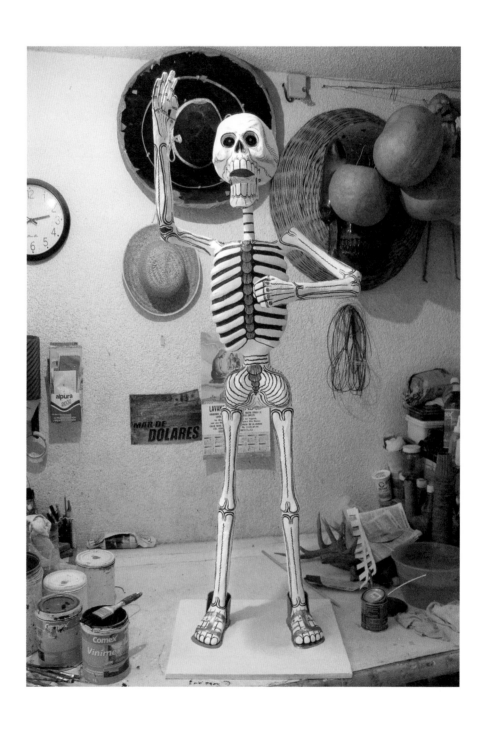

Above Leonardo Linares Vargas, Skeleton in progress, Mexico City, 2009
Opposite Don Felipe's grandson Israel holding a half-finished skull of papier-mâché, Mexico City, c.2000

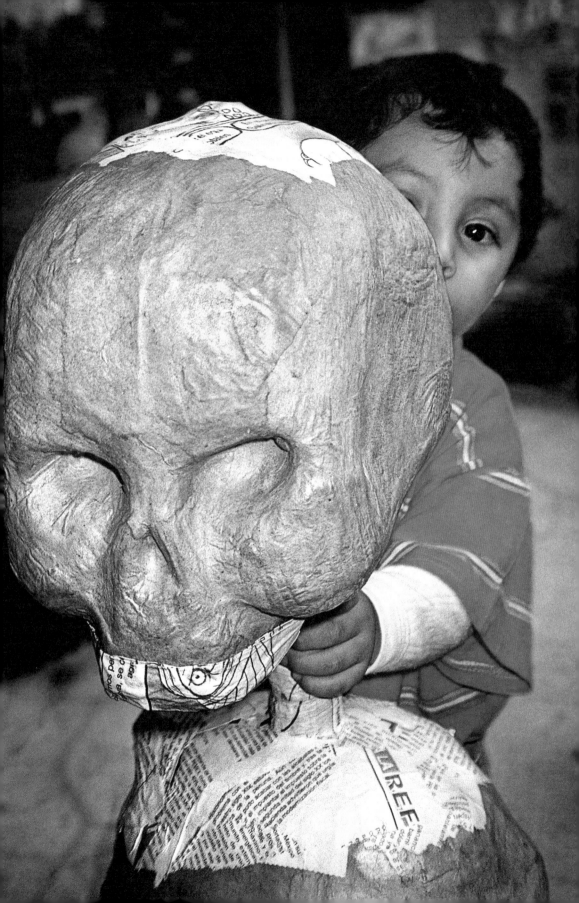

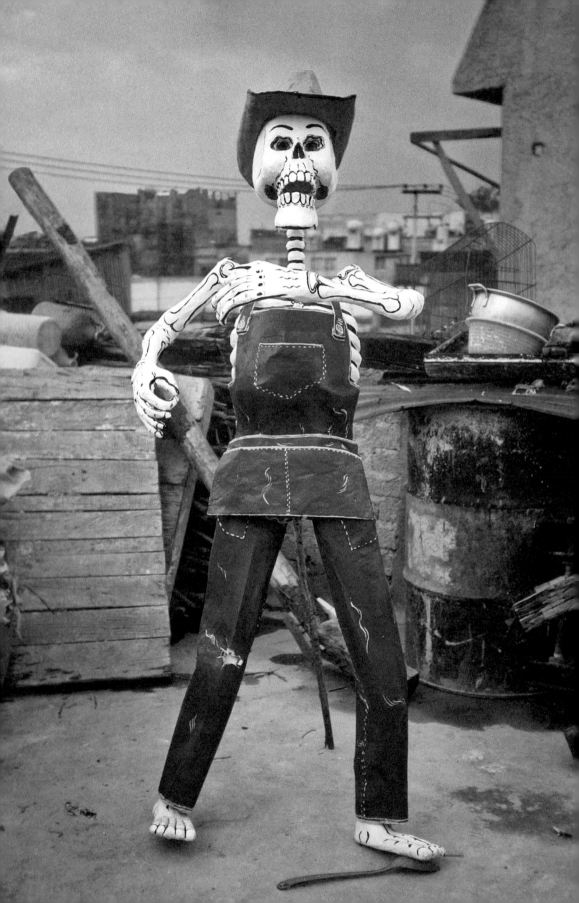

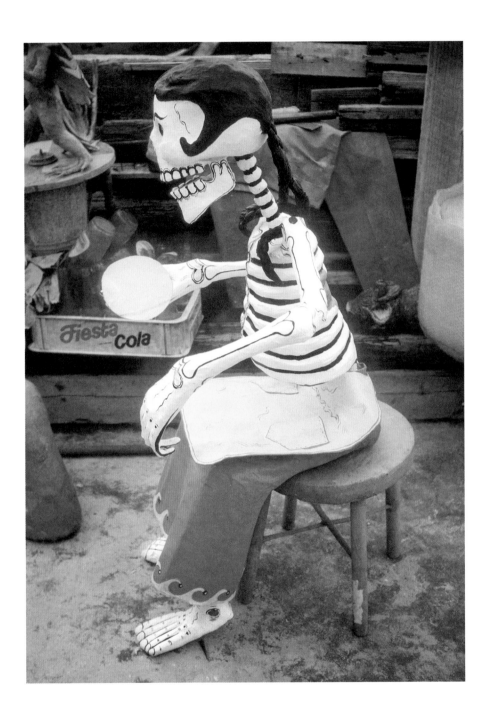

Felipe Linares Mendoza, Papier-mâché figures drying outside
the rooftop workshop, Mexico City, 1988
Opposite Workman wearing denim overalls
Above Woman making tortillas

201

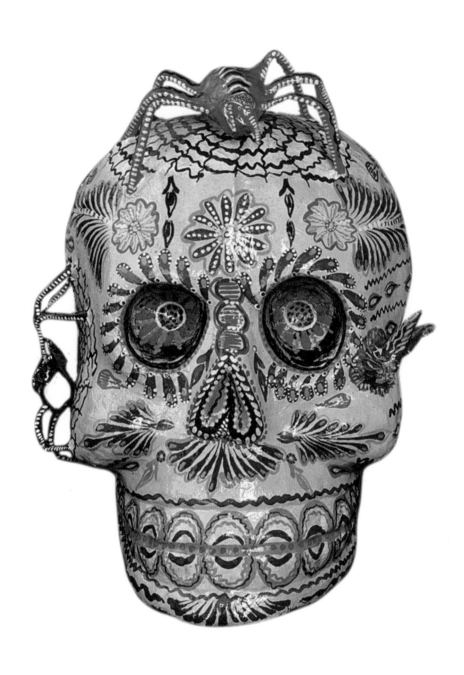

Above and opposite Miguel Linares Mendoza,
Decorated papier-mâché skulls, Mexico City, c.1976

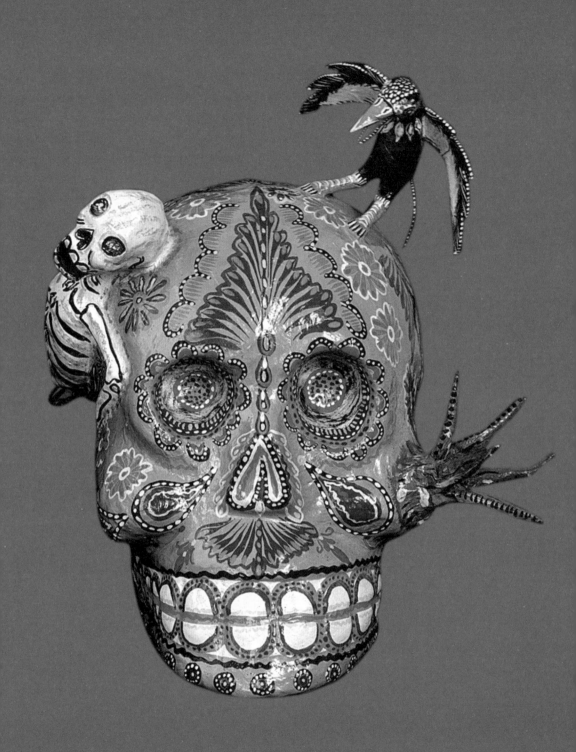

7

DEATH IN FOCUS:
YOLANDA ANDRADE

Photography has a long history in Mexico.

In 1839, the invention of the daguerreotype was announced in France. Barely six months later, photographs started to appear in Mexico. Many early practitioners—both Mexican and foreign—focussed on travel and exploration, recording ethnographic, archeological, and natural sights. Portrait studios also flourished. Photographers such as Romualdo García (1852–1930) posed clients in front of painted backdrops. His portraits of grieving mothers with their dead children are shown on pages 38 and 39.

The twentieth century brought the spread of newspapers and the rise of photojournalism, and images of railroads and ambitious engineering projects promoted Mexican achievements and invited foreign investment. These were superseded after 1910 by photographs of the Mexican Revolution and by a nationalist desire to rediscover Mexico's cultural roots. The modernization and expansion of Mexico City during the 1940s and 1950s provided a wealth of subject matter for documentary photographers and filmmakers. In recent decades, urban growth and social inequality remain key themes.

Yolanda Andrade was born in 1950 in Villahermosa in the state of Tabasco, but moved to Mexico City in 1968 to study theater. This vast metropolis became, and remains, her home. When she committed herself to photography in 1974, her project became the city and its multiplicity of layers. Working initially in black and white, then moving on more recently to color, she describes herself as a "street photographer." Public spaces are an endless source of human drama, as people pursue their everyday and ceremonial lives. For Andrade, as for the celebrated French photographer Henri Cartier-Bresson (1908–2004), the challenge is to capture the "'decisive moment" in a single frame. Her photographs, shaped by her meticulous eye for composition and symbolism, reveal the physical and the transcendental. The magical meets the mundane, and poetic possibilities are juxtaposed with comic absurdities. As Andrade explains, modernization, history, faith, and tradition collide in the vibrant and "carnivalesque" world of Mexico City.

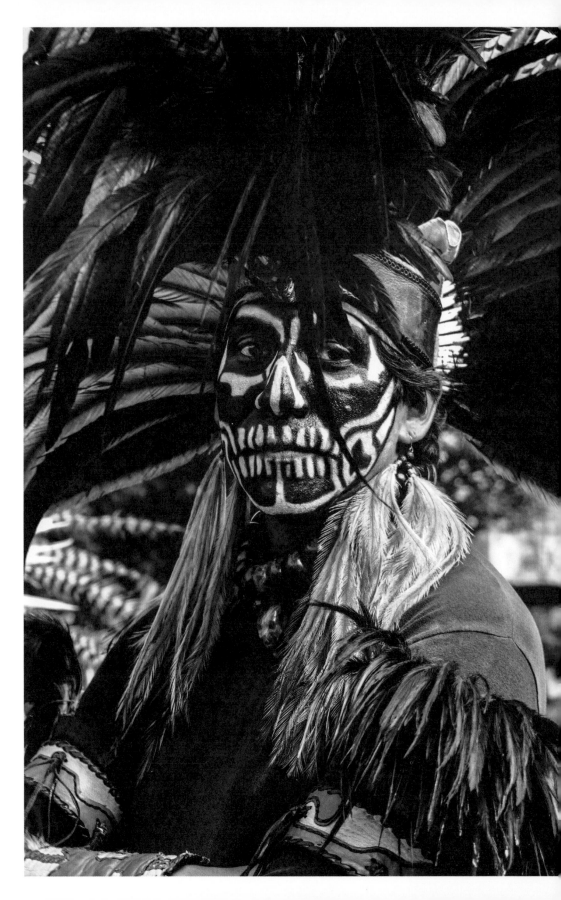

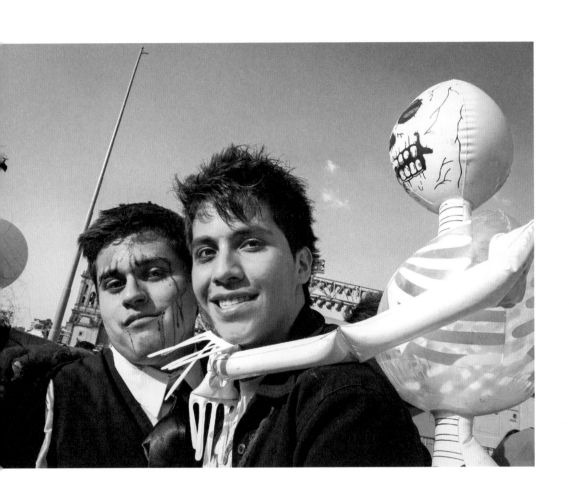

Opposite *Day of the Dead*, Mexico City, 2019
Above *Halloween during the Day of the Dead*, Mexico City, 2010

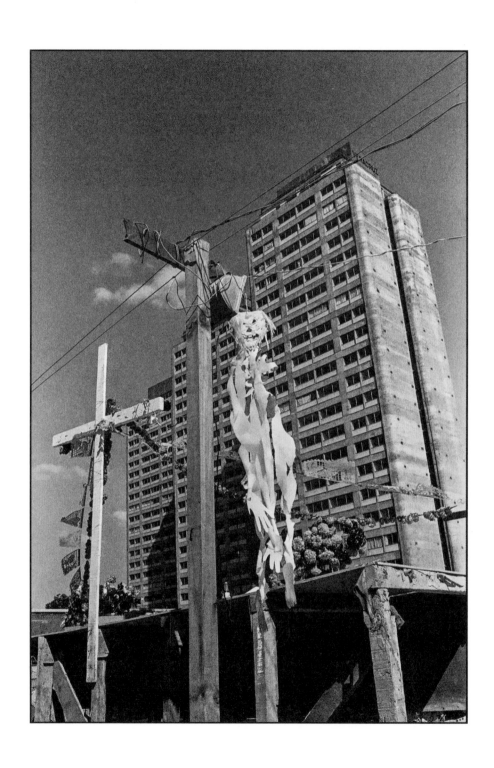

Above *Death in Tlatelolco*, Mexico City, 1989
Opposite *Altar for the Dead in La Alameda*, Mexico City, 2004

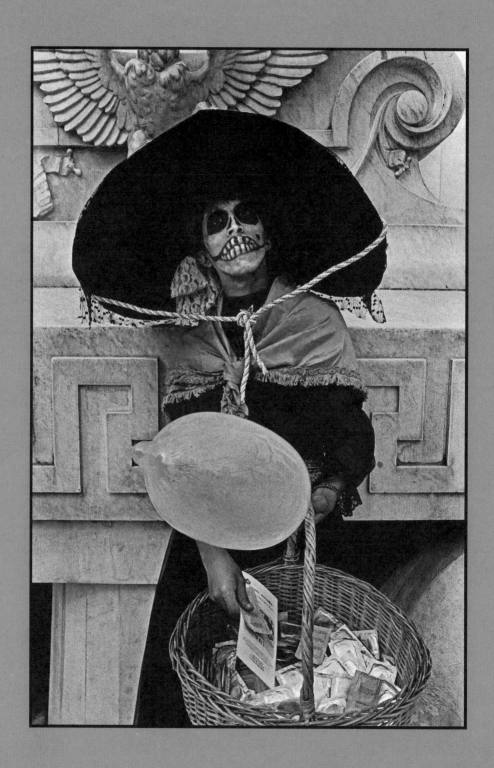

Death is ceremony,
theater, and ritual.

Yolanda Andrade

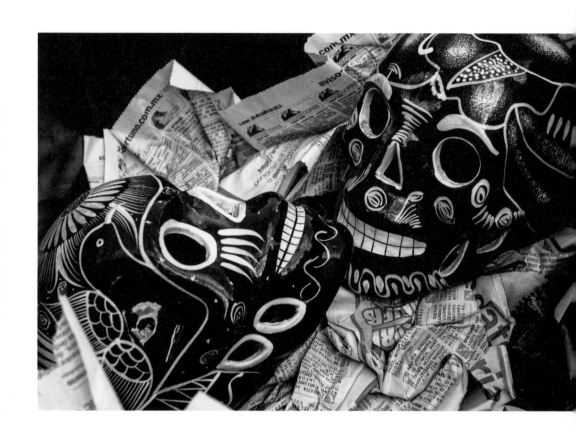

Above *Smiling Skulls*, Mexico City, 2015
Opposite *Death on Stilts*, 1993

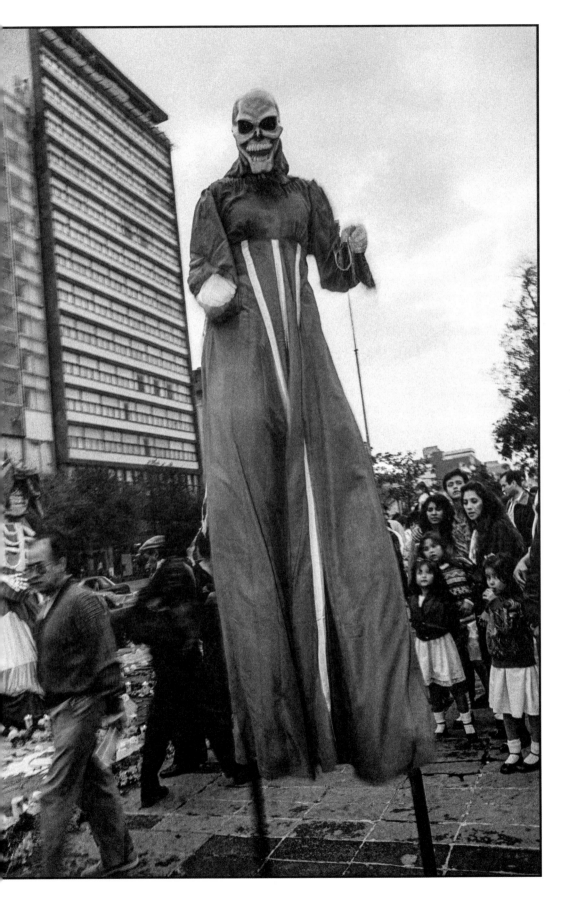

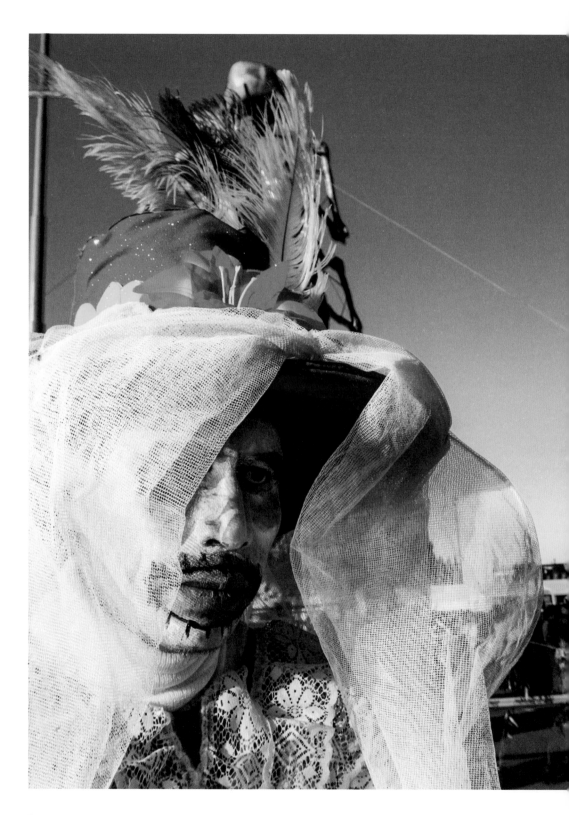

The Sad Catrina, 2005

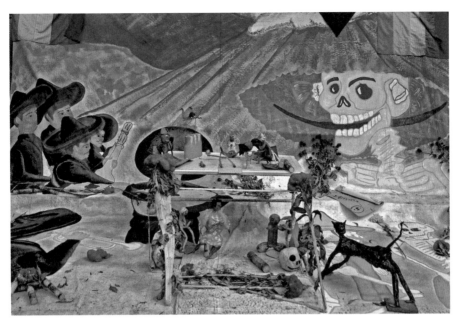

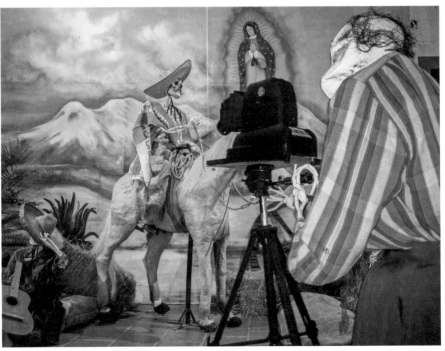

Top *Still Life of the Day of the Dead*, Mexico City, 2004
Above *The Photographer*, Naolinco, Veracruz, 2009

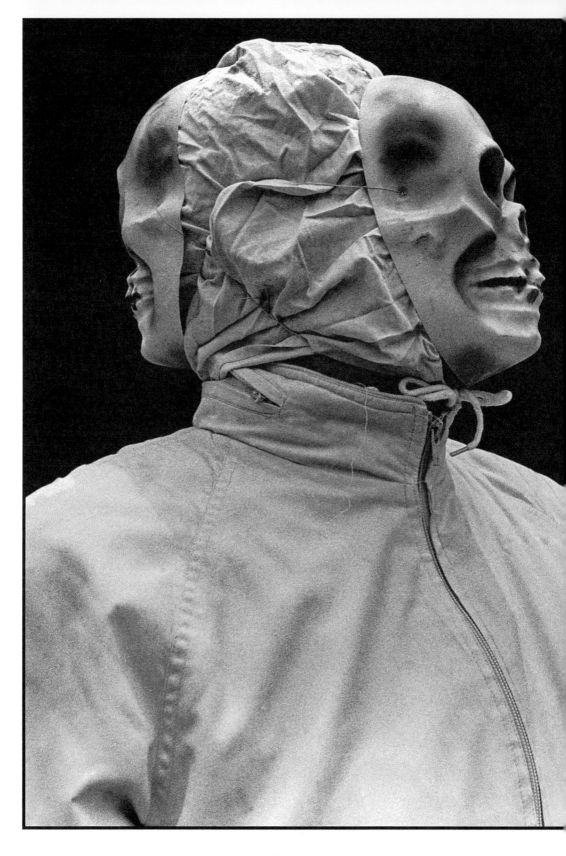

As You See Me, You Will See Yourself, Mexico City, 1990

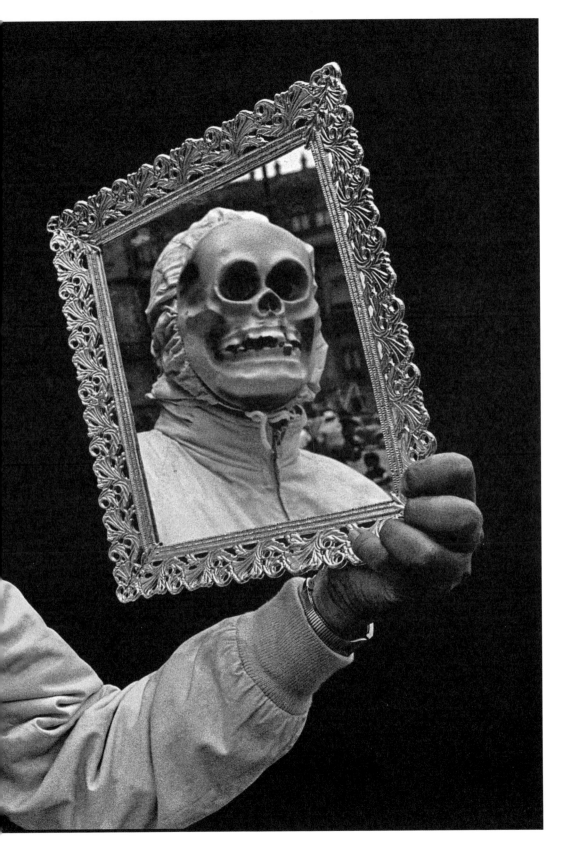

Extended Captions

p.20 *Tzompantli* (skull rack), painted in Indigenous style, from the Codex Tovar (also known as the Codex Ramírez), c.1587. The skulls of sacrificial victims were pierced and displayed in the sacred precinct of the Aztec capital. Also shown are twin temples dedicated to the gods Tlaloc (left) and Huitzilopochtli (right). Sixteenth-century friars often borrowed material from each other. *The History of the Indies of New Spain*, known as the Codex Durán because it was compiled by Diego Durán (c.1537–1588), probably formed the basis for this codex. The Maya and other pre-Conquest cultures also erected racks to display trophy-skulls.

p.23 Page from the Codex Borgia, painted on deerskin in Central Mexico in Mixteca-Puebla style, c.1500. Two paired deities, shown back-to-back, frame a divination cycle. Mictlantecuhtli (left) is the skeletal god of death and the underworld. Ehecatl (right), the long-beaked wind god, is associated with creator god Quetzalcoatl the Feathered Serpent. Together they embody the principle of duality in Aztec thought. They stand over an upside-down mask representing the underworld. Day signs from the *tonalpohualli* (260-day ritual year) appear beside the central image.

p.24 Disk of andesite, with traces of red paint, showing Mictlantecuhtli (the god of death) surrounded by rays. Located in front of the great Pyramid of the Sun at Teotihuacán (1–650CE), the disk was probably linked to human sacrifice and to the Night Sun of the underworld. The setting and rising of the sun reflected the death and rebirth of the solar system. Some scholars think that this disk could have been taken to Teotihuacán long after its demise by the Aztecs, who revered and were inspired by this ancient city.

p.32 José Guadalupe Posada (1852–1913) made thousands of engravings, but is chiefly remembered today for his satirical *calaveras*. Born in Aguascalientes, he moved in 1889 to Mexico City, where he worked for several publishers including Antonio Vanegas Arroyo (c.1850–1917). This witty *calavera* portrays Don "Toncho" as a skeleton, still writing in his grave. Illustrations by Posada, and by his predecessor Manuel Manilla, were adapted and reused by Vanegas Arroyo to suit changing requirements. Occasionally Posada remade his plates with subtle variations. It is difficult, therefore, to accurately date much of Posada's work. Satire, by its very nature, is ephemeral. Because these images were printed on cheap paper, only a small number survive. In the 1920s, Posada's prints were rediscovered by the French artist Jean Charlot (1898–1979). They were also admired in the 1930s by André Breton, founder of the Surrealist movement.

p.33 Don Chepito appeared in several broadsides illustrated by José Guadalupe Posada. A figure of fun, he sometimes bore the name Don Chepito Mariguano ("Dopehead"). Aging and deluded, he experienced various misadventures and disappointments. In one broadside, having fancied himself as a toreador, Don Chepito was gored by the bull. In this *calavera, Don Pepito (Chepito) contempla a las Presentes*, he gazes at the skulls of former beauties.

p.35 *La Orquesta* (1861–77) was a popular Mexican periodical specializing in political cartoons. The artist and illustrator Constantino Escalante (1836–1868) is regarded today as the "father" of political caricature in Mexico. This *calavera*, published on November 4, 1865 (vol. 1, no 97) reads: "I need a few dozen of these skulls for my Don Juan Tenorio, which is being performed tonight at the Palacio Imperial." This play, written in 1844 by the Spanish dramatist José Zorrilla y Moral (1817–1893), is traditionally performed in Mexico during the Days of the Dead.

pp.38, 39 Photographs of loved ones, taken after their death, could seem morbid to modern sensibilities, yet post-mortem photography

was prevalent in many parts of Europe and the Americas. Before photography, painted mourning portraits allowed the wealthy to permanently preserve the image of the dead. From the mid-19th century onwards, photography allowed families of all social classes to commemorate the deceased. Romualdo García (1852–1930) is recognized as one of Latin America's finest portrait photographers. For almost 60 years, he ran a successful portrait studio in Guanajuato. His many clients included grieving mothers and sometimes fathers. The death of infants was common, and post-mortem photographs served as precious keepsakes.

pp.58, 59, 60–61 Sergei Eisenstein (1898–1948) spent just over a year in Mexico. The avant-garde Russian filmmaker was accompanied by cinematographer Edward Tisse (1897–1961) and assistant Grigory Alexandrov (1903–1983). Between December 1930 and February 1932, they shot dozens of hours of footage. *¡Qué Viva México!* was planned as an epic representation of Mexican history that would meld politics, people, and ritual. Although Eisenstein was prevented from completing his film, variously edited versions were later put out by Alexandrov and others. Eisenstein's Day of the Dead sequences were edited by Sol Lesser and released in 1934 as *Death Day*.

p.70 Bicycles were newly fashionable when Antonio Vanegas Arroyo published this *calavera*. The message is clear: "From this famous hippodrome on the racetrack, no single journalist is missing. Inexorable death shows no respect, not even for those seen here on bicycles." Each skeleton has the name of a newspaper and an identifying visual trait. For example, Posada shows *El Tiempo* (Time) with wings like Chronos.

p.82 Eugenio Reyes Eustaquio is a professional altar builder in Huaquechula, Puebla. Before the Days of the Dead, villagers who have died during the preceding year are honored with spectacular

satin-covered *ofrendas*. This exact replica was made by Eugenio while he was a guest of the British Museum in 1991. It formed part of the exhibition "The Skeleton at the Feast: The Day of the Dead in Mexico" (Museum of Mankind, 1991–3).

p.88 In the state of Oaxaca, some families make sand paintings (*tapetes de arena* or sand "mats") on the ground in front of their *ofrendas* to welcome the deceased. Celebrated ceramic artist Angélica Delfina Vásquez Cruz (b.1958) created this shimmering low-relief image of Our Lady of Guadalupe using an extensive palette of dyed sand and glitter. In 2009, she brought honor to her town, Santa María Atzompa, when she was awarded the Premio Nacional de Ciencias y Artes in the category of Arts and Traditions.

p.114 Roberto Ruiz (1928–2008) was born in Miahuatlán, Oaxaca, and moved in 1961 to Ciudad Nezahualcóyotl on the outskirts of Mexico City. He taught himself to carve wood, then started to carve bone using a dentist's drill. A celebrated miniaturist, he was awarded the Premio Nacional de Ciencias y Artes in the category of Arts and Traditions by the Mexican government in 1988. Death was a favorite subject, and he greatly admired the *calaveras* of José Guadalupe Posada.

pp.116–17 Procession led by La Catrina. In 2004, during the Belfast Festival, artist Humberto Spíndola choreographed the event for Queen's University. Played by an Irish actress, La Catrina wore a paper costume created by Spíndola. She addressed the crowd in English and led a joyous parade through the streets.

p.144 In Oaxaca, religious processions called *calendas* often include brass bands and dancers who carry large "puppets" on their shoulders. Called *mojigangas* or *monos de calenda*, these have a painted papier-mâché head above a clothed bamboo frame. The final destination for this festive pilgrimage is the church.

Bibliography

Ajofrín, Francisco de, *Diario del viaje que hizo a la América en el siglo XVIII el P. Fray Francisco de Ajofrín*, Galas de Mexico, 1964

Andrade, Yolanda (introduction by K. Mitchell Snow), *Pasión Mexicana—Mexican Passion*, Conaculta-Fonca, 2002

Ankori, Gannit, *Frida Kahlo* (Series: Critical Lives), Reaktion Books, 2018

Arizpe, Lourdes, *El Patrimonio Cultural Inmaterial de México: Ritos y Festividades*, Conaculta, 2009

Arqueología Mexicana, *La muerte en México de la época prehispánica a la actualidad*, Editorial Raíces, 2013

Brandes, Stanley H., *Skulls to the Living, Bread to the Dead: The Day of the Dead in Mexico and Beyond*, Blackwell, 2006

Brenner, Anita, *Idols Behind Altars*, Brace and Company, 1929

Canales, Claudia, *Romualdo García: Un fotógrafo, una ciudad, una época* (Series: Artistas de Guanajuato), Ediciones La Rana, 1998

Carmichael, Elizabeth, and Chloë Sayer, *The Skeleton at the Feast: The Day of the Dead in Mexico*, British Museum Press, 1991

Casademunt, Tomás, *La muerte en el altar*, Editorial RM, 2009

Durán, Fray Diego, *Book of the Gods and Rites and the Ancient Calendar* (ed. and trans. Fernando Horcacitas and Doris Heyden), University of Oklahoma Press, 1971

Eisenstein, Sergei M. (trans. William Powell, ed. Richard Taylor), *Beyond the Stars: The Memoirs of Sergei Eisenstein*, Seagull Books, 1995

Faudree, Paja, *Singing for the Dead: The Politics of Indigenous Revival in Mexico*, Duke University Press, 2013

Fernández de Calderón, Cándida, et al., *Grandes Maestros del Arte Popular Mexicano*, Fomento Cultural Banamex, 1994

Frank, Patrick, *Posada's Broadsheets: Mexican Popular Imagery, 1890–1910*, University of New Mexico Press, 1998

Freund, Gisèle, et al., *Frida Kahlo: The Gisèle Freund Photographs*, Abrams, 2013

Gagnier de Mendoza, Mary Jane, *Oaxaca: Family, Food and Fiestas in Teotitlán* (with photography by Ariel Mendoza), Museum of New Mexico Press, 2005

Garciagodoy, Juanita, *Digging the Days of the Dead: A Reading of Mexico's Días de Muertos*, University Press of Colorado, 1998

Garibay K., Ángel María (ed. and trans.), *Poesía náhuatl*, UNAM Instituto de Investigaciones Históricas, 1964

Geduld, Harry M., and Ronald Gottesman (eds), *Sergei Eisenstein and Upton Sinclair: The Making and Unmaking of ¡Qué Viva México!*, Indiana University Press, 1970

Gruzinski, Serge, *Painting the Conquest: The Mexican Indians and the European Renaissance*, Flammarion, 1992

Hernández Hernández, Alberto (coordinator), *La Santa Muerte: Espacios, cultos y devociones*, El Colegio de la Frontera Norte/El Colegio de San Luis, 2016

Herrera, Hayden, *Frida: A Biography of Frida Kahlo*, Harper & Row, 1983

Kahlo, Frida (introduction by Carlos Fuentes, essay by Sarah M. Lowe), *The Diary of Frida Kahlo: An Intimate Self-Portrait*, Bloomsbury Publishing, 1995

Kissam, Edward, and Michael Schmidt (trans.), *Flower and Song: Aztec Poems*, Carcanet Press, 1977

Lomnitz, Claudio, *Death and the Idea of Mexico*, Zone Books, 2005

López Casillas, Mercurio, *Manilla: Monografía de 598 Estampas de Manuel Manilla*,

Grabador Mexicano, Editorial RM, 2005

——, et al., *La Muerte en el impreso mexicano/Images of Death in Mexican Prints*, Editorial RM, 2008

Masuoka, Susan N., *En Calavera: The Papier-Mâché Art of the Linares Family*, Fowler Museum of Cultural History, 1994

Matos Moctezuma, Eduardo, *Muerte a filo de obsidiana: Los nahuas frente a la muerte*, Fondo de Cultura Económica, 2008

——, et al., *Miccaihuitl: El Culto a la Muerte*, special issue of *Artes de México*, no.145, 1971

——, with Felipe Solis Olguín et al., *Aztecs*, Royal Academy of Arts, 2002

Monsiváis, Carlos, et al., *Belleza y Poesía en el Arte Popular Mexicano*, Consejo Nacional para la Cultura y las Artes, 1996

Mulryan, Lenore Hoag, et al., *Ceramic Trees of Life: Popular Art from Mexico*, UCLA Fowler Museum of Cultural History, 2003

Murdy, Ann, *On the Path of Marigolds: Living Traditions of Mexico's Day of the Dead*, George F. Thompson Publishing, 1919

Museo de Arte Popular, Mexico City, *Cuatro manos, dos oficios: Una iconografía—Carlomagno/Jacobo Ángeles* (exhibition catalogue), 2014

Museo Universitario de Ciencias y Artes, Mexico City, *La Muerte: Expresiones Mexicanas de un Enigma*, Dirección General de Difusión Cultural (UNAM), 1975

Norget, Kristin, *Days of Death, Days of Life: Ritual in the Popular Culture of Oaxaca*, Columbia University Press, 2006

Nutini, Hugo G., *Todos Santos in Rural Tlaxcala: A Syncretic, Expressive, and Symbolic Analysis of the Cult of the Dead*, Princeton University Press, 1988

——, "Day of the Dead and Todos Santos," in *The Oxford Encyclopedia of Mesoamerican Cultures: The Civilizations of Mexico and Central America*, Vol. 1, pp.311–14, Oxford University Press, 2001

Oettinger, Marion Jr., *Folk Treasures of Mexico: The Nelson Rockefeller Collection*, Harry N. Abrams, 1990

Oles, James, *Art and Architecture in Mexico* (Series: World of Art), Thames & Hudson, 2013

Paz, Octavio, *The Labyrinth of Solitude: A Dramatic Portrait of the Mexican Mind* (trans. Lysander Kemp), Allen Lane, Penguin Press, 1967

Pomar, María Teresa, *El Día de los Muertos: The Life of the Dead in Mexican Folk Art* (exhibition catalogue), The Fort Worth Art Museum, 1987

—— (ed.), *Alfeñique*, Conaculta, 2004

Posada, José Guadalupe, *José Guadalupe Posada: Ilustrador de la vida mexicana*, Fondo Editorial de la Plástica Mexicana, 1963

Ricard, Robert, *The Spiritual Conquest of Mexico: An Essay on the Apostolate and the Evangelizing Methods of the Mendicant Orders in New Spain, 1532–1572*, University of California Press, 1974

Salvo, Dana (photographer) et al., *Home Altars of Mexico*, William H. Beezley, 1997

Sayer, Chloë, *Arts and Crafts of Mexico*, Thames & Hudson, 1990

—— (ed.), *Mexico: The Day of the Dead*, Redstone Press, 1990

——, "Saulo Moreno: An Interview with Chloë Sayer," in "New Art from Latin America: Expanding the Continent," *Art & Design Magazine*, Academy Group, 1994

——, *Fiesta: Days of the Dead and Other Mexican Festivals*, British Museum Press, 2009

Starr, Frederick, *Catalogue of a Collection of Objects Illustrating the Folklore of Mexico*, Published for the Folk-Lore Society by David Nutt, 1899

Thelmadatter, Leigh Ann, *Mexican Cartonería: Paper, Paste and Fiesta*, Schiffer Publishing, 2019

Toor, Frances, *A Treasury of Mexican Folkways*, Crown Publishers, 1976

Westheim, Paul, *La Calavera*, Biblioteca Era, 1971

Wollen, Peter (ed. Julian Rothenstein), *Posada: Messenger of Mortality*, Redstone Press, 1989

Credits & Acknowledgments

Pages 20 Museo Nacional de Antropología; **21** Chloë Sayer; **23** Apostolic Library of the Vatican; **24–5** Chloë Sayer, Coll. Museo Nacional de Antropología; **37** Unknown photographer; **56–7** Agustín Jiménez; **58–9, 60–61** kindly provided by Lutz Becker; **72–3** Juan Guzmán, courtesy of Throckmorton Fine Arts; **74** © Photo: Jorge Contreras Chacel/Bridgeman Images. © Banco de México Diego Rivera Frida Kahlo Museums Trust, Mexico, D.F./DACS 2021; **75** © Photo: Christie's Images/Bridgeman Images. © Banco de México Diego Rivera Frida Kahlo Museums Trust, Mexico, D.F./DACS 2021; **82** David Lavender; **83, 84, 85, 87, 88, 89 top, 89 bottom, 90–91, 92, 93, 96, 97, 98, 99** Chloë Sayer; **102–3** Chloë Sayer; **104–5** Gisèle Freund, Archive; **106** © 2021 Schalkwijk/Art Resource/Scala, Florence. © Banco de México Diego Rivera Frida Kahlo Museums Trust, Mexico, D.F./DACS 2021; **107** © 2021 Schalkwijk/Art Resource/Scala, Florence. © Banco de México Diego Rivera Frida Kahlo Museums Trust, Mexico, D.F./DACS 2021; **114** David Lavender, Coll. British Museum; **116–17, 118** Chloë Sayer; **119** David Lavender, Coll. Chloë Sayer; **122–3** Chloë Sayer. © Banco de México Diego Rivera Frida Kahlo Museums Trust, Mexico, D.F./DACS 2021; **124, 125** David Lavender, Coll. Chloë Sayer; **126** Chloë Sayer; **127** David Lavender, Coll. Chloë Sayer; **134–5** Ulises Ruiz/AFP via Getty Images; **136, 137, 138, 139, 140–41, 144, 145, 146, 147 top, 147 bottom** Chloë Sayer; **148–9** Efrain Padro/Alamy; **156–7** Chloë Sayer; **158** David Lavender, Coll. Chloë Sayer; **160, 161** Chloë Sayer; **162, 163, 164** David Lavender, Coll. Chloë Sayer; **165, 166, 167, 169** Chloë Sayer; **170, 171** David Lavender, Coll. Chloë Sayer; **172** Chloë Sayer; **173** David Lavender, Coll. Ortiz-Sayer British Museum; **174–5, 176–7** Chloë Sayer; **178, 179** David Lavender, Coll. Chloë Sayer; **182, 183** Chloë Sayer; **184** David Lavender, Coll. Chloë Sayer; **185, 191, 192–3, 194, 195, 198, 199, 200, 201** Chloë Sayer; **202, 203** David Lavender, Coll. Ortiz-Sayer British Museum; **208, 209, 210, 211, 212, 214, 215, 216, 217 top, 217 bottom, 218–19** Yolanda Andrade

Uncaptioned images on the following openers are by José Guadalupe Posada: pp.4, 6, 14, 40, 43, 76, 94, 101, 108, 128, 143, 150, 186, 204

Translations on pp.7–9, 26, 27, 42, 46, 53, 56, 62–3, 95, 100, 121, 142, 159, 176, 180–1, 197 Chloë Sayer; p.86 Lysander Kemp; p.115 John Paul Sayer.

Chloë Sayer would like to thank Jim Nikas for his invaluable help sourcing images by José Guadalupe Posada and Manuel Manilla.